LOGOS LETTERHEADS & BUSINESS CARDS

DESIGN FOR PROFIT

Conway Lloyd Morgan and Chris Foges

RotoVision

A Rotovision Book
Published and distributed by Rotovision SA
Route Suisse 9
CH-1295 Mies
Switzerland

Rotovision SA, Sales & Production Office
Sheridan House, 112/116A Western Road
Hove, East Sussex BN3 1DD, UK
Tel: +44 (0) 1273 72 72 68
Fax: +44 (0) 1273 72 72 69
E-mail: sales@rotovision.com
www.rotovision.com

10 9 8 7 6 5 4 3 2 1

ISBN 2-88046-750-0

Logos design by Wendy Williams
Letterheads & Business Cards design by
Struktur Design

Production and separations in Singapore
by ProVision Pte. Ltd
Tel: +65 6334 7720
Fax: +65 6334 7721

Logos by Conway Lloyd Morgan

Letterheads & Business Cards by Chris Foges

Contents

Letterheads & Business Cards

introduction
wearing the sign

'Cars today are almost the exact equivalent of the great Gothic cathedrals: I mean the supreme creation of an era, created with passion by unknown artists. Roland Barthes' essay 'The New Citroën' is included in *Mythologies*, his seminal text on products, design and society. He analysed the form of the 1950s Citroën DS (and lots of other things, from margarine to striptease) in social and perceptual terms, a semantic approach that he was among the first to devise, and which provided a spur to the development of issues such as brand management and product semantics. And the Citroën double V logo is a key part of this analysis – the Citroën emblem, with its arrows, has in fact become a winged emblem, as if one was proceeding from the category of propulsion to that of spontaneous motion, from that of the engine to that of the organism.'

Barthes was right to focus on the Citroën logo (originally devised to reflect the angled intermeshing gears that were invented by André Citroen). Logos form a key part of the branding of a product or service, and of the corporate identity of a company or institution. Historically, logos predate branding and identity: the samurai with the banner of his daimyo fluttering behind his armour, the feathered headdress and body-painting of the Native American, and the Scot wearing a clan tartan, are all using external elements to signify their adherence to a set of values or concepts that are expressed visually. As do the football supporters with their faces painted in the team colours, the pensioners who put their modest purchases from a corner shop into a Harrods carrier bag or the

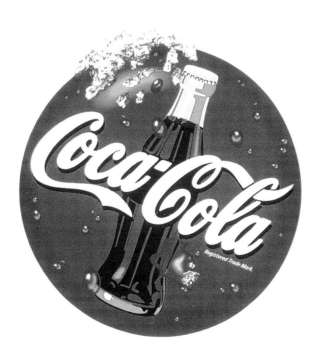

introduction
wearing the sign

teenagers who will only go to a disco in Versace jeans (even fake ones). The desire to identify oneself through emblems is an age-old human trait. At certain times in history it was a necessity – to establish rights or even to act as a form of public warning – as in the physical branding of criminals or the Nazis' deliberate humiliation of Jews through the wearing of the Star of David.

In most modern societies displaying the wrong signs – or wearing the wrong colours – is a social gaffe, not a life-threatening situation. But that does not mean that we are unaware of such signs, or even less that the manufacturing and service enterprises and companies that underpin modern societies are ignorant of the latent power of such signs. In fact, our understanding of such signs grows increasingly profound. To take the example of television advertising, twenty years ago it was dedicated to the selling of specific products and services: buy this soap, it said, or use this airline. Today the message is couched in different terms, whatever the specifics on offer. The consumer is not just asked to purchase but also to believe. Trust this soap with your body. This airline cares about your dreams.

This is not merely a change from hard to soft sell: it is part of a process of sophistication in which both the manufacturers' intentions and the customers' expectations have become more subtle, and in which, for the advertiser, convincing not only immediate purchasers but long-term potential purchasers has become cardinally important in maintaining market presence. As part of the same process the logo, a visual summary of the company's identity, has become the vehicle for expressing the philosophy and position of the company; become not just a means of identification – like a flag or banner – but a means of communication.

And so the design of logos, which a generation ago was simply about finding a neat visual solution to a name, is today a much more complex process, which feeds back into the internal culture of a corporation and outwards into the market's perception of its activities and offers. So the design process for logos has become inseparable from the concepts of branding and corporate identity – which in turn can be subsumed into a wider concept of corporate culture. At the heart of the idea of corporate culture is the idea of focus – that all the manifestations of a corporation, from the way its letters are worded or its annual reports illustrated, from the tactics of its softball team to the launch of a new product range – all elements are coherent with a specific view of what the corporation is and represents. So a failure of communication at any level threatens the totality.

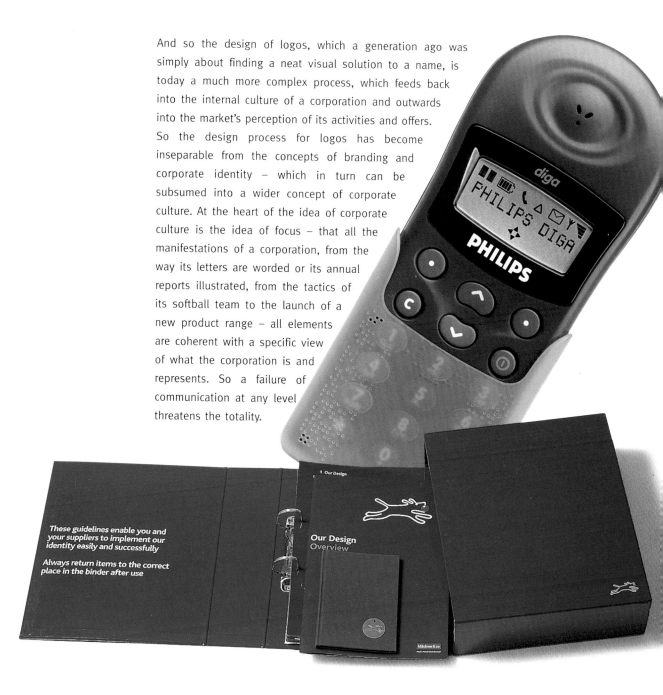

These guidelines enable you and your suppliers to implement our identity easily and successfully

Always return items to the correct place in the binder after use

Our Design
Overview

introduction
wearing the sign

The political validity or desirability of such a view of corporate culture is not here at issue: suffice it to say that the concept of the corporation as a dedicated single organism is the objective of much modern management teaching and practice. Whatever methods are used to create the final result, there is now little doubt that the logo (or brand or marque or corporate identity) plays a major role in creating and defining the corporate culture. For the logo designer, the consequences of this change are clear enough. The previously valid, visually derived solution is evidently inadequate, and what is needed are solutions sourced in an understanding of corporate values and aspirations. Once these are understood, a visual metaphor can be derived from them. As the case studies in this book show, this is a challenge that makes the designer's task more interesting, if also more difficult, and which endows the visual solution with a validity that goes beyond simple aesthetics.

So this is a change and a challenge which any and every designer should relish. It is clear that communication between people and peoples is essential for the continuation of peaceful society, and so that designers, as agents of communication, have a special social responsibility to express and maintain civic values. (If this seems exaggerated, look at the way design, along with other kinds of visual imagery, has been used to promote social ideas and political concepts over the last fifty years.)

The practical consequence of the foregoing for a designer invited to advise on a new logo or branding or identity design is that any client brief is likely to be inadequate in terms of the real problems to be considered. This is a drawback which can be turned into an opportunity, provided that it is understood that an intellectual appreciation has to precede a visual solution. Each case is different, as the studies of real design projects that follow show. But there are common features, or stages, through which each design progresses.

The first of these is understanding the brief, or more specifically the context of the brief. The designer's first task is to understand the values and aspirations of the client: this is the research phase. Next is the establishment of a dialogue with the client so that the visual ideas can be translated into concepts the client understands. This leads to the design solution, which has to be communicated to the client and through the client corporation. Since new identities are often the vehicle for changes in corporate culture and self-perception, this stage is often as important as the new visual material. Finally the design has to be implemented: a manual produced on paper or CD-Rom, monitoring procedures set up, the purpose behind the design explained. And, with time, the design needs to be developed to respond to changing circumstances and requirements.

In this book we have presented the designs under headings that relate to this process – the background, the research phase, the solution – and added an assessment of each design. The designs have been grouped under logos, identities, brands and culture. But all show how designers today are using their skills in different forms of communication, and witness the complexity, challenge and enjoyment of working in the corporate field.

what

A logo is a distinguishing mark for a company, a product, a service or a range of products or services from the same source.

A logo is unique to the company it represents, and can be protected legally as a trademark, trade name or registered mark.

A logo can be typographical, figurative, abstract or can be a combination of these.

A logo is one of the base elements in a corporate identity or brand identity.

A logo can be two or three dimensional, monochrome or coloured (though there is normally a two-dimensional version for a three-dimensional logo and a black-and-white version for a coloured one).

is a logo ?

A logo is the basic design equity owned by a company, alongside the company name. Say 'International Business Machines' and most people won't know what you mean. Say IBM and they will understand you in most languages! The IBM logo, designed by Paul Rand in the 1950s, has become a benchmark for quality in typewriters (IBM was a pioneer in developing electric and then electronic typewriters in the USA), in computer systems (the IBM company nickname 'Big Blue' comes, it is said, from the colour of the casings of the room-sized computer systems it was installing for major corporations in the 1950s and 1960s, though another theory is that IBM executives always wore blue suits) and in personal computers. (The Open Systems Architecture and QDOS programming adopted by IBM became the standard on which the personal computer revolution of the last decade was built.) The IBM logo has not been changed or modified since its introduction. It therefore stands alongside (and stands for) the qualities of reliability and efficiency which are the company's reputation. 'No-one ever got fired for buying IBM' is an old joke, but one which encapsulates the solidity of IBM's market position. It is a professional, business-to-business offer, based on mutual respect between partners. There is an interesting comparison here with the Apple Mac proposition, which is based on creativity and personal expression, rather than efficiency. Apple users have a fierce dedication to the product, seeing themselves as the computer revolutionaries, while in fact it was IBM's decision to base its PC on an open system that fuelled the computer revolution. While the IBM logo is part of a wider and very sophisticated corporate identity, which extends into corporate policy on architecture and sponsorship, the logo is the cornerstone of the company's image. It represents an asset of incalculable value, because it has been consistently maintained and protected over the years.

THE SAVOY

LAWYERS COMMITTEE FOR HUMAN RIGHTS

OXYGEN/ATOMIC SKI

TECHNIQUEST

CEARNS & BROWN

THE IBM PRODUCT RANGE
INCLUDES THE THINKPAD
AND THE APTIVA

Be our guest

C L I E N T
Savoy Hotel Group
London, UK

D E S I G N E R S
Pentagram Design
London, UK

P R O D U C T / S E R V I C E
Prestiges hotels

the background

The Savoy in London is synonymous with luxury: it has a worldwide reputation for ordered elegance. I used to at one time travel to work on the same train as one of the banqueting managers. He would wear an immaculate grey, swallow-tail coat and striped trousers every day, even if he knew there was no function that day demanding his appearance, and he would be in his office all the time! The train was normally full of overnight arrivals at Heathrow, red-eyed and time-warped: he must have come as something of a surprise to them.

But established success is no guarantee of the future. The services guests expect from a luxury hotel change, and the origins and backgrounds of the guests themselves change as well, especially in an international meeting-point like London. One way of dealing with this change is by fragmentation: creating different areas in the hotel for different guest needs – a busy brasserie for younger guests, a formal library bar for older ones, for example. The drawback to this approach is that it blurs the overall identity by trying to be too many things.

The Pentagram group was invited to advise the Savoy Group on the identity not only of the Savoy but of the two other luxury hotels they own in central London: The Berkeley and Claridge's. The principle question was, should there be uniform group identity across all three, or should each have its own identity? If there was to be an overall identity, what should it be, or, if there were to be individual identities, what should they be?

SAVOY

The designers were asked for a new identity for this famous hotel group: the typographic solution is simple and direct, conveying the formal luxury that awaits guests in these very individual hotels with

THE BERKELEY

Claridge's

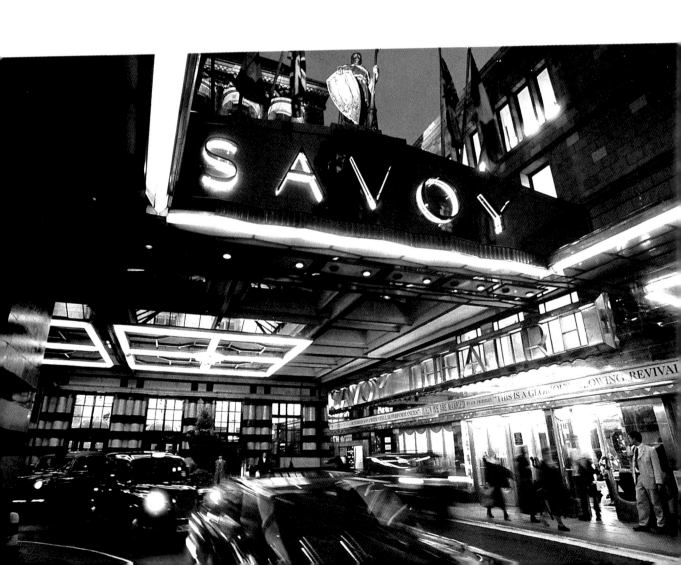

the solution

To answer the main question, Pentagram sought to analyse the advantages and disadvantages that would arise from a uniform style. In its view the advantages of a shared look (for example, in advertising the hotels overseas) were outweighed by the disadvantages. Each hotel was different, in terms of location, architectural style and ambience, and in their market would lose out from being perceived as part of a chain. This answer is not surprising, but the advantage of analysing the situation was that it brought the designers and the management up to date on customer and public perceptions of the three hotels. In other words, though they had little doubt about the overall answer they would get, the detail in the answers was valuable for the next phase – designing the individual logos. For the three graphic identities, Pentagram realised that simplicity, or rather singularity, was the key to maintaining the standing of the hotels. Previous logos had either become very quickly dated, or had not been sufficiently well defined to operate under changing circumstances. Their proposal was therefore for a largely typographical solution in each case, the choice of typeface being determined by the character of each hotel. So the word Savoy was set in gold sans serif uppercase lettering, with the V larger than the rest. This is direct and eloquent, and a neat reference to the immense awning that greets the arriving visitor in Savoy Street. Claridge's, which is a rather more exuberant hotel, uses a busy serif typeface with some decorative scrolling. The Berkeley, in Knightsbridge, uses formal serif capitals.

By rights

CLIENT
Lawyers Committee
New York, USA
for Human Rights

DESIGNERS
Lippa Pearce
Richmond, UK

PRODUCT/SERVICE
Human rights organisation

the background

In recent years charities and pressure groups have become aware of the need for clear visual identities to support their important work. This is partly a response to the growing visual awareness of society at large and the opportunity to present information visually, partly a response to the increasing range of public voices seeking the public's support for good causes, and partly a reflection of the growing international reach of many such issues.

Since 1978 the Lawyers Committee for Human Rights has sought to mobilise the legal community across the world to secure and promote the rights guaranteed by the International Bill of Human Rights. It now has a worldwide network of national groups, and actively lobbies international organisations and governments from its base in New York. The Committee works in conjunction with other groups such as the Witness Programme founded by Peter Gabriel, who also supports the Committee. Its constituency extends from national and international bodies to human rights activists, lawyers and, most importantly, the victims of persecution themselves. In 1996 the Committee decided that a redesign of its logo on a worldwide basis was needed, and asked the British firm Lippa Pearce to help.

The brief asked for a logo that would reflect in some way the core concerns of the Committee, would transcend national boundaries, and be appropriate for the range of different audiences . It would be used on stationery, signage, web sites and publications. The main constraint was that the logo should be carefully budgeted, and function in monochrome and in colour. The core concerns of the Committee are justice, fairness, equality and impartiality in the application of law, together with a respect for the principles of the International Bill of Human Rights.

'Design only works when it is based on a solid foundation of ideas, coherent, clear objectives and rational or emotional response triggers.' Harry Pearce.

LAWYERS COMMITTEE
FOR HUMAN RIGHTS

the brief

The challenge was to find a symbol for an international human rights group that could be read visually in different cultures and still convey directly the concerns of the group. The logo had to be adaptable not only to letterheads but also for publications and information videos.

LAWYERS COMMITTEE
FOR HUMAN RIGHTS

Washington, D.C. Office:
100 Maryland Avenue, N.E.
Suite 502, Washington, D.C. 20002

Telephone (202) 547 5692
Facsimile (202) 543 5999
E mail WDC @ lchr. org

330 Seventh Avenue
10th Floor New York
New York 10001

Telephone (212) 629 6170
Facsimile (212) 967 0916
E mail NYC @ lchr. org

LAWYERS COMMITTEE
FOR HUMAN RIGHTS

Washington, D.C. Office:
100 Maryland Avenue, N.E.
Suite 502, Washington, D.C.
20002

Telephone (202) 547 5692
Facsimile (202) 543 5999
E mail WDC @ lchr. org

LAWYERS COMMITTEE
FOR HUMAN RIGHTS

L.Camille Massey
Director, Communications

330 Seventh Avenue
10th Floor New York
New York 10001

Telephone (212) 629 6170
Facsimile (212) 967 0916
E mail NYC @ lchr. org

the research

Lippa Pearce's approach to any design brief is to analyse the brief before starting the visual design process. In the case of the Committee, it looked at various factors. First came the existing identity, to monitor its strengths and weaknesses, and the identities of other pressure groups in the same field, to establish norms for the area. Then there were the needs of the organisation, requiring information about use of the new logo and the culture of the organisation, so that the new logo would speak in the right 'tone of voice', and the core values of the organisation and their meaning within and without the organisation, would achieve expression through the logo. Finally, there was the environment where the identity would be put to work, and the expectations and requirements of that environment, consisting of the legal profession, government and the media.

Lippa Pearce used this research process to identify a number of different design routes and took these to a more developed visual for preliminary presentation to the client. Design routes allow the opportunity to explore different tones of voice and different creative solutions. Seven alternatives were studied for the Lawyers Committee, in part because of the need for a design to cross national

and cultural boundaries. Two of these, chosen initially for further development, are shown here. One uses the visual idea of a bracket to link the support of the committee for human rights; another transforms the H of human rights into an icon of prison bars. These designs and the preliminary version of the final design were presented over a two-day period to the Committee Board and to members and staff of the Committee. The executive director of the Committee then presented the selected design to groups of international activists: among the aspects discussed at all these stages was whether the design risked offending any national or religious sensibilities.

Analysing the alternative designs, it is clear that the bracket solution depended on reading a typographic device that might not be immediately apparent to all cultures. And if the title of the Committee was translated into foreign languages the layout of elements might change, so losing consistency. The prison bars approach also depended on reading the icon back into the letter H (again not appropriate in cultures where the roman alphabet is not the norm) and suggests a concentration on penal issues while the work of the Committee is wider in scope.

'The power of the symbol is its simplicity and grace – the basic concept of people working together towards a common goal.' Peter Gabriel, founder of the Witness Programme.

COLOUR CODING IS USED ON
STATIONERY TO DENOTE
DIFFERENT FUNCTIONS

the solution

The final design can be read figuratively in a number of ways: an individual (in white) supported by a committee (in black), a witness before a jury, a leader fronting a team, even as a victim facing oppressors. In this way it addresses the concerns of all its potential audiences. As it is an abstract image it risks no offense, while having the independence and strength of a formal mark. Read typographically, it can be considered as based on the letter I, for international. It is deliberately classical, mature and serious, reflecting the tone of voice of the client. The four objectives Lippa Pearce set itself were authority, clarity, simplicity and longevity, representing the Committee's steadfast and direct purpose, its strength and maturity in the field, and its endurance and independence.

THE LOGO AS USED ON NEWSLETTERS, PUBLICATIONS AND SIGNAGE.

the assessment

With the final logo design approved, the designers turned to the additional aspects of the design: the colour palette, associated typefaces and logos. The logo itself could be used as a positive or reversed symbol, and in and against a range of colours. These were defined in turn according to the objectives (red, for example, was excluded as a colour because of its political links, and the format and typography for newsletters and documents were to be clear, formal, businesslike and experienced). On letterheads, the logo appears in positive, with colours for different areas and functions, with the title of the committee on two adjoining lines in serif capitals. For publications, serif types were selected for their professional and human values, sans serifs for their clarity and legibility. The underlying principle was that directness of communication would contribute to the credibility and authority of the organisation. In the words of Camille Massey, communications director for the Lawyers Committee on Human Rights 'we are delighted to possess an identity that beautifully represents our organisation and will ultimately allow our human rights work to have a much greater impact worldwide.'

LAWYERS COMMITTEE
FOR HUMAN RIGHTS

← Reception

↑ Meeting
rooms 1·6

← Information
Centre

330 Seventh Avenue

Inflating
the image

C L I E N T
Oxygen/Atomic Ski *Vienna, Austria*

D E S I G N E R S
Rage Design *West Wycombe, UK*

P R O D U C T / S E R V I C E
Inline skates and accessories

the background

Inline skating is street cred at pavement level. It is about dexterity, control, style, performance and appearance. How you move is part of how you look, whether you are skating for fun or for fitness. The appearance of the skates is part of their appeal, and is supported by accessories such as bags and caps, pouches and helmets, wristguards and gauntlets.

The branding, including the logo, of fashion/sports goods such as these is therefore critical to their market performance: the logos and marks represent an important design equity. So the Oxygen name in its encircling oval logo figures prominently on the skates themselves, on their packaging, and on accessories and printed material.

When Oxygen decided to extend its operations in Europe, it called in Rage Design who were already working on a number of sport/fashion accounts, for help with their printed material. 'One service we offer to a lot of our American clients,' Rick Gaskell of Rage Design explains, 'is getting their ideas and images into a European context. It won't work today just to carry copy or presentations across from the USA to Europe or the UK directly. We need to redirect them for Europe, if you like. And so we are producing material in several European languages, for example.' He felt that the Oxygen logo needed some repositioning. 'Clearly it was an established brand and those values had to be respected and enhanced. But it was a little stiff in its appearance, which might have been a problem in languages such as German where the word would not be immediately known.'

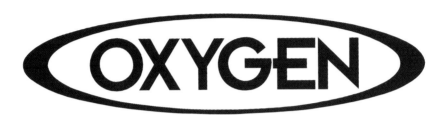

the brief

An established brand in the sports/leisure field in one market (in this case the USA) may need to be
modified slightly for European tastes, particularly as the products involved (inline skates) are aimed

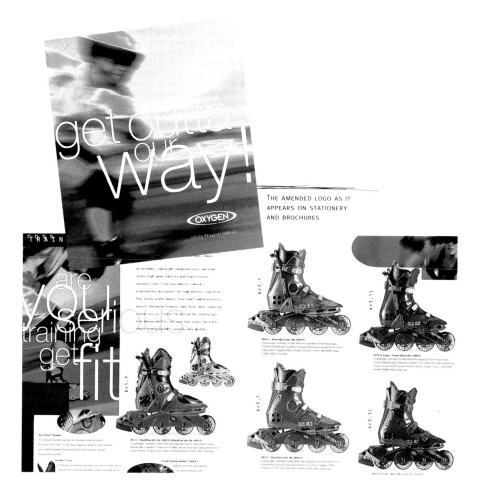

THE AMENDED LOGO AS IT
APPEARS ON STATIONERY
AND BROCHURES

the solution

'We decided to put a bit of air into Oxygen,' Gaskell jokes. For the letterheads and cards for the new European company, based in Austria, Rage retained the existing logo, while printing it out of silver rather than out of white, and producing a second, inflated shadow version, which runs at an angle under the address panel, and is printed in a washed-out blue. The oval shape is also reinforced by a pattern of three blue ovals that form a graphic positioning feature on business stationery. Although visually soft, this change actually gives the brand more immediacy and attack. It positions it clearly in the tough world of youth culture and sports culture.

Do anything.
Go anywhere.
Just go for it!

This speeded-up version of the logo is also used as a graphic feature in the catalogue and other printed material, and as a visual backing element on packaging designs for smaller items. It is an adjunct to the main logo, not intended to compete with it at all, rather, in supporting the main name, giving it

Seeking science

CLIENT
Techniquest
Cardiff, South Wales, UK

DESIGNERS
HGV
London, UK

PRODUCT/SERVICE
Science centre

the background

The redefinition of the museum is one of the most exciting aspects of late 20th-century culture. Rather than being just a static treasure house of objects and artifacts from the past, the modern museum has taken on a new role as a centre for learning, explanation and demonstration: an active rather than a passive role. This change has created the opportunity for new kinds of cultural or informational activity, not necessarily linked to holdings of rare or old objects, but with the same functions of informing and entertaining. The new Techniquest centre, created from the ruins of earlier industrial glory in the former docks area of Cardiff, is an example of the latter: a new space devoted to explaining the basics of science, for children – defined by Pierre Vermier, founder of HGV, as 'like with Tintin, children from the ages of seven to 77'.

The new Techiquest space is in a former warehouse, transformed by architects ORK into a white and open environment with an additional geodesic dome: it is the largest interactive science centre in the United Kingdom. HGV was asked to provide signage, graphics and a visual identity. The main constraint on the design was the budget, which was very small. The installations themselves, which demonstrated basic principles of science, especially physics, through physically interactive games, had been largely designed by the time HGV became involved, though it was able to work alongside the centre's staff in terms of colour and instructional material.

The main aim of the centre was 'to convey the questioning nature of learning about science', and the key terms derived from research both for the identity design brief and for the main installation design were colourful, flexible, and simple. 'We decided to use four primary colours – red, yellow, blue and green – in strong tones,' Vermier explains, 'as these were direct and fun, and so met the requirements of the brief.' A similar range of colours, together with white and transparent materials, was used in the interactive exhibits, so locking the two elements together.

TECHNIQUEST

the brief

An interactive science learning centre for young people needs to make an immediate visual appeal.
The use of primary colours and a simple visual pun not only met the brief for the logo but also
formed a basis for packaging and promotional items.

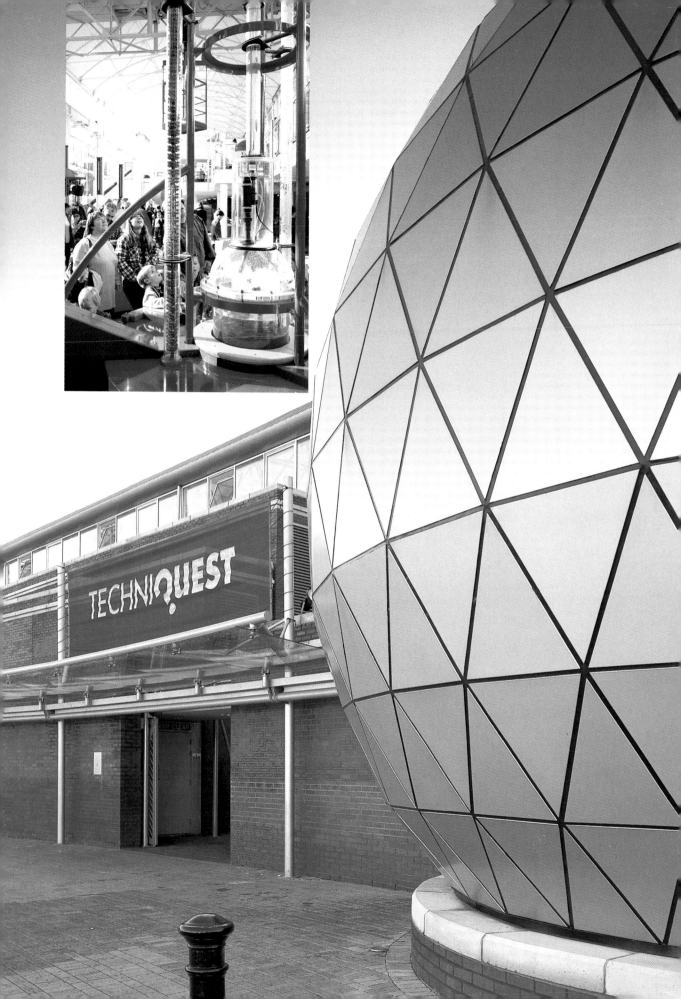

the **solution**

For the name Techiquest a direct visual pun was the solution: take the letter Q and substitute a ?, set at an angle. This was further refined by using standard sans serif capitals for the first six letters, and an extra-bold form of the same face for the balance. The question mark sits at the point of change, which in fact makes it easier to read as a Q, rather than otherwise. The angled question mark is also used as an independent element, for example on wrapping paper and packaging, and the colours are combined across the complete range of possibilities. 'There is no hierarchy of colours,' according to Vermier. 'The external signage is yellow on blue, as that has both high visibility, and works best with the colours of the external facade. But the director's business card uses red on green.'

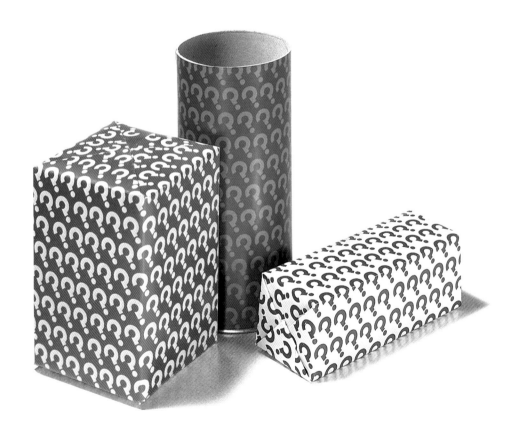

ALTERNATIVE COLOURWAYS
FOR THE USE OF THE LOGO
ON BADGES AND BROCHURES
AND THE QUESTIONMARK
MOTIF ON PACKAGING

the assessment

A number of complementary elements to the final solution have yet to be achieved because of budget: one such is a large exterior mobile, designed by Vermier, with circular discs advertising the centre and specific attractions or sponsored events. But otherwise the new identity and signage has been very well received, contributing to a doubling of attendance figures for the new centre. The success of the identity design stems from the simplicity of its elements and the verve with which they have been developed – even down to the coathangers in the cloakrooms being coloured and patterned to match the question mark design.

Move the meal

CLIENT
Cearns & Brown
Runcorn, UK

DESIGNERS
Wolff Olins
London, UK

PRODUCT / SERVICE
Food distributors and manufacturers

the background

Office canteens have been replaced in recent years by office catering, and schools, hospitals and other public services have increasingly been contracting-out catering services. As a result, the market has become more complex and competitive. In the north of England, the long-established firm of Cearns & Brown has been supplying local kitchens and caterers with food products for many years. Half of its business was wholesaling for other manufacturers, half was selling its own products under the 'Countrywide' brand name. The result was that for some customers, the company was perceived as a food supplier, for others just a delivery service. To build a stronger market for its own brand, and to unify the two aspects of the business (which were not different, in fact, but were perceived as such) the company consulted Wolff Olins in London.

Wolff Olins realised when they researched the situation that the company needed to be seen as food specialists offering a service to a specific market: physical delivery was a key part of the business, but the assurance of product quality was far more important. What was needed was an image that would represent quality, and which could be modified to carry the concept of service. Furthermore, the company's clients were also food specialists – caterers, chefs and kitchen staff. The people who would handle and use the products were professionals working in a busy environment. What they wanted was to put their hands on what they needed at the moment they needed it. Most of the several hundred products in the Cearns & Brown/Countrywide range were basics for the catering kitchen: tinned vegetables and fruits, pre-prepared sauces, pastas and rice. Thus the more direct the offer, the more successful it was likely to be, provided it spoke the right language to the user.

CEARNS&BROWN

the brief

The brief asked for a way of bringing the two strands of the client's business (food products and distribution) together in the eyes of their customers. A simple photographic approach with occasional touches of wit is the right solution for the professional market addressed.

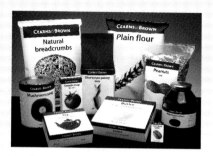

the solution

Wolff Olins borrowed the computer screen maxim – 'what you see is what you get'. The packs simply show what is inside them: tomatoes on the tinned tomatoes, beans on the tinned beans, apples on the apple sauce. The products are shown in colour; the descriptions are on a uniform green band on a white background. The photography is straightforward: 'we had three months to create 700 packaging designs,' Lee Coomber of Wolff Olins jokes, 'so we didn't have time for a lot of retouching work.' Stylised photography would in any case have undermined the direct delivery implicit in the overall approach.

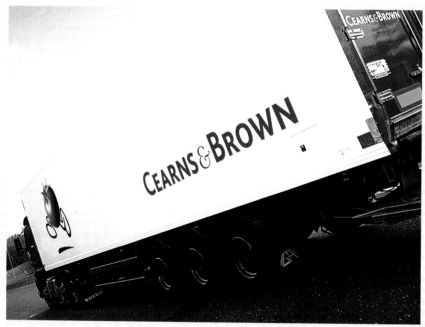

THE BASIC IMAGERY USED ON
PACKAGING IS GIVEN A GRAPHIC
TWIST FOR STATIONERY AND
VEHICLE LIVERY

CEARNS&BROWN

Cearns & Brown
Whitehouse
Runcorn
Cheshire WA7 3BL

Tel: 01928 7155555
Fax: 01928 712582

CEARNS&BROWN

Cearns & Brown
Whitehouse
Runcorn
Cheshire WA7 3BL

Tel: 01928 7155555
Fax: 01928 712582

with compliments

Cearns & Brown Limited
Registered office: Whitehouse
Runcorn Cheshire WA7 3BL
Registered number: 123 456

CEARNS&BROWN

Whitehouse
Runcorn
Cheshire
WA7 3BL

Alexandra Parker
Marketing Co-ordinator

Tel: 01928 712345
Fax: 01928 714441

Cearns & Brown Limited
Registered office: Whitehouse
Runcorn Cheshire WA7 3BL
Registered number: 123 456

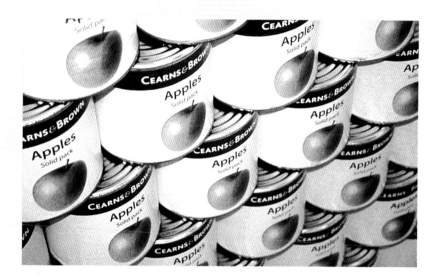

the development

For the vehicle livery, wit was the answer: take a tin or a bottle, furnish it with hand-drawn feet or wings, and use it large on the side of a white delivery truck or van. The result is highly visible, immediately links the delivery system to the product range, and has a light touch that suggests not levity but enthusiasm. Wit and humour in design are especially valuable in media that are, by their nature, ephemeral, such as television and press advertising, and often this is a more interesting approach than using the old war-horses of sex and luxury. In the context of identity design, humour is almost impossible to achieve, but a certain lightness (but not light-heartedness) can provide an antidote to the solid and sometimes overbearing expressions of corporate power that categorise some identities.

The running and flying tins and bottles are also used on some of the products that are 'customer-facing', such as sauce bottles and condiments, products that will come out of the kitchen and on to the serving area of a canteen or a pub counter. This makes a gentle link with a wider public, who may have seen a tin of tomatoes flying past on the motorway.

'Every time you see it, it works a little harder'

Lee Coomber

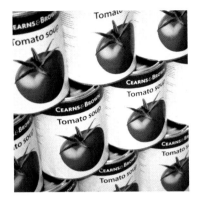

Price list

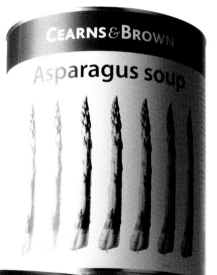

REPETITION OF SIMPLE ELEMENTS IS THE KEY TO THE SUCCESS OF THE DESIGN

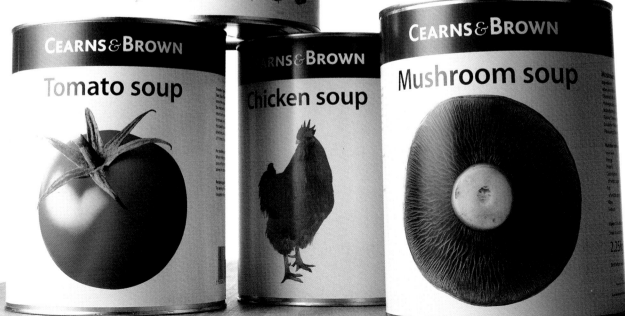

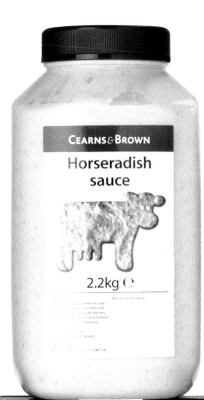

CEARNS&BROWN

Horseradish sauce

2.2kg ℮

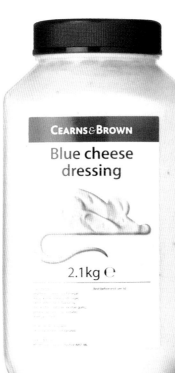

CEARNS&BROWN

Blue cheese dressing

2.1kg ℮

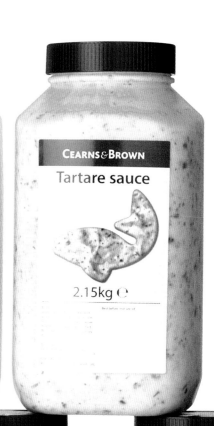

CEARNS&BROWN

Tartare sauce

2.15kg ℮

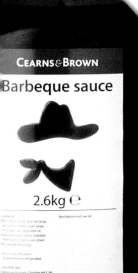

CEARNS&BROWN

Barbeque sauce

2.6kg ℮

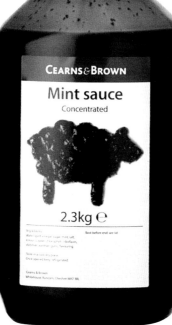

CEARNS&BROWN

Mint sauce
Concentrated

2.3kg ℮

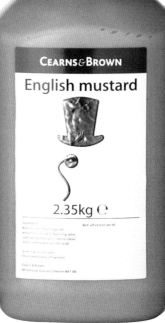

CEARNS&BROWN

English mustard

2.35kg ℮

CEARNS&BROWN

French vinaigrette

2.2kg ℮

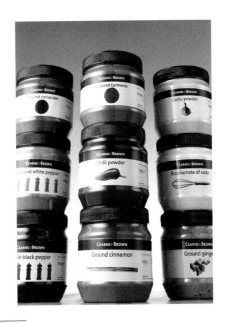

the assessment

The base identity, expressed mainly through the packaging, as well as on letterheads and price lists, is simple and almost understated. It relies for its effect on regular contact, and the skill behind Wolff Olins' solution lies in the realisation that it is precisely in this way that the product will be seen and used by the eventual clients. Through regular use, the identity becomes, in Coomber's words, 'a style, or even a language, which is repeating gently the assurance of quality that is at the heart of the offer.' Such an approach would have been quite ineffective in a retail context, but here has considerable subtlety. It also binds the main offer to the parent company very effectively.

GRAPHIC WIT APPLIED TO
CUSTOMER-FACING PRODUCTS
SUCH AS SAUCES

what is a corporate identity?

A corporate identity is the visual statement of a company's role and function, a means of visual communication internally with its shareholders and employees and externally with its suppliers and customers.

A corporate identity consists of the logo and name (or names and logos) owned by a company together with the rules and guidance on how these are to be used; for example, in printed material such as letterheads, catalogues and reports, in advertising, marketing and promotion, and on products and services.

A corporate identity often specifies which colours and typefaces are to be used with logos and names, and the desired relationship between them. Such colours and typefaces can also be among the design equities owned by the company.

A corporate identity is one of the base elements of a corporate culture. Robert Blaich, when he was head of the design section at Philips, the Dutch electronics giant, once pointed out to me that there was only one Siemens in the Munich telephone directory, thereby giving the company's Bavarian rival a head start in protecting its corporate name and identity. The name Philips, however, could not be protected as a word. So part of his task, as well as supervising the design of products ranging from razors to radios and lamps to laptop computers, was to create a corporate identity system that would link the product range with the company, and with the corporate values of innovation and quality, in the public mind worldwide. Since Philips' operations were truly global, consistency was essential, not only to protect the company's identity as compared to other businesses using, quite legitimately, the Philips name, but also to maintain Philips' position in a highly competitive marketplace. Blaich and his team at Eindhoven realised that the key to consistency was simplicity. Anything too complex was likely to fail, either through misinterpretation or through lack of attention to detail. They also wanted to be certain, at the time, that local printers anywhere in the world would have the necessary resources for printing letterheads or cartons or price lists for their local offices. So they adopted Univers, probably the most widely available typeface in the world, together with Times, as the corporate typeface, and 100 per cent cyan as the standard corporate colour, in which the Philips name would be printed. The second requirement for a consistent identity is rigour: the rules for every utilisation imaginable of the company name had to be considered and rules established. They therefore published a manual, running to some 600 A4 pages, setting out in detail the positioning, sizing and presentation of the Philips name (and any associated brand names or product names) in all situations on catalogues, on packaging, on products, and in advertising in whatever media.

Today the same information is available electronically, on CD Rom or over the corporate intranet, as a system of templates for the use of the name. But the groundwork was essential. Only once this basis for coherence was in place could the more complex work of projecting the company's image be developed and sustained.

PHILIPS

Let's make things better.

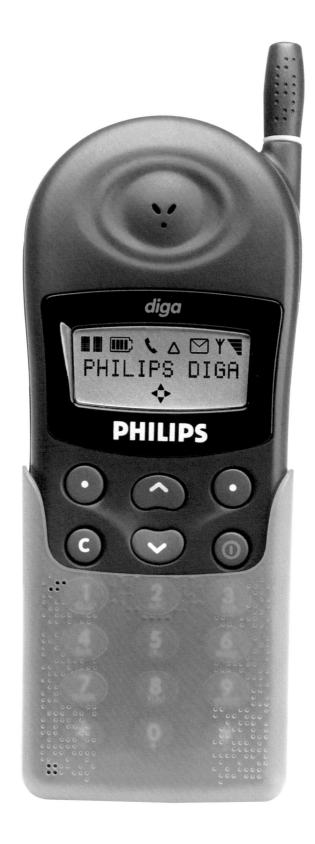

THE IDENTITY OF THIS
MOBILE PHONE COMES
NOT ONLY FROM THE
CAREFULLY-PLACED NAME
BUT FROM THE DESIGN
VALUES OF THE PRODUCT

Clearing the way

CLIENT
Hong Kong Government
Hong Kong

DESIGNERS
Alan Chan and Springpoint
Hong Kong London, UK

PRODUCT/SERVICE
Hong Kong International Airport Core programme

the background

The full opening of the new Hong Kong Airport, scheduled for late 1998, will mark the conclusion of the largest transport infrastructure project in the world. Not just the creation of an airport able to handle 87 million passengers and nine million tonnes of freight annually, but a bridge 300 foot longer than the Golden Gate bridge in San Francisco, a new motorway and rail service, and a new city for 200,000 people. All this is being built on a group of islands in Hong Kong Bay (yes, it's the world's largest land reclamation project as well).

香 港 機 場 核 心 計 劃
HONG KONG AIRPORT
CORE PROGRAMME

the brief

The construction of the new Hong Kong airport affected the lives of tens of thousands of people in the city. The brief for a project logo was aimed at facilitating communication between the team building the airport and the communities, business interests and political authorities involved or touched by the

the research

This very high profile undertaking had to be explained to a large number of constituencies; firstly to the people of Hong Kong itself, whose daily lives would be affected by three or four years of construction work; secondly to the political, business and financial communities in Hong Kong and China; and thirdly to a wide range of international business interests, for whom Hong Kong is seen as a central feature in the business landscape of South East Asia. This task needs communication skills, and so the Hong Kong Government approached Alan Chan, a designer based in Hong Hong, and the London-based consultancy Springpoint, to advise them on getting 'the right message to the right people'. It rapidly became clear that the scale of the project made it of central importance not only to Hong Kong and China but also to the whole Pacific area, indeed even to the world. One key concept was Interlink, which referred not only to the chain of islands where the airport and the new city were to be built, but also to the transport links between site and existing city.

Further verbal concepts were developed using 'brainstorming' sessions of Cantonese, Mandarin and English speakers (as any names found had to be acceptable in all three languages). Some idea of the scale of the programme can be judged by the fact that these sessions were only to produce a first list of one thousand possibilities. This multi-lingual approach was necessary in view of the range of different constituencies and agencies with whom the design had to communicate.

At the same time a number of graphic ideas were studied, towards developing a visual approach to graphic communication. These visual studies included abstract images, as well as forms based on the rich tradition of Chinese imagery, in which, for example, the dragon symbolises strength and goodness, and the phoenix is associated with peace, prosperity and plenty.

the solution

The final design was created by Mark Pierce of Springpoint. It can be read on a number of levels. Firstly, as an image of a plane in flight. Secondly, as representations of air, land, and water. Thirdly, through its calligraphic style, as both classical and contemporary, as well as Chinese. And fourthly, it recalls the Chinese ideogram for three, representing the trinity of land, sea and air, or travel in all three media.

'More than just a symbol, the new identity adds up to an unmistakable and unique visual language'
Fiona Gilmore

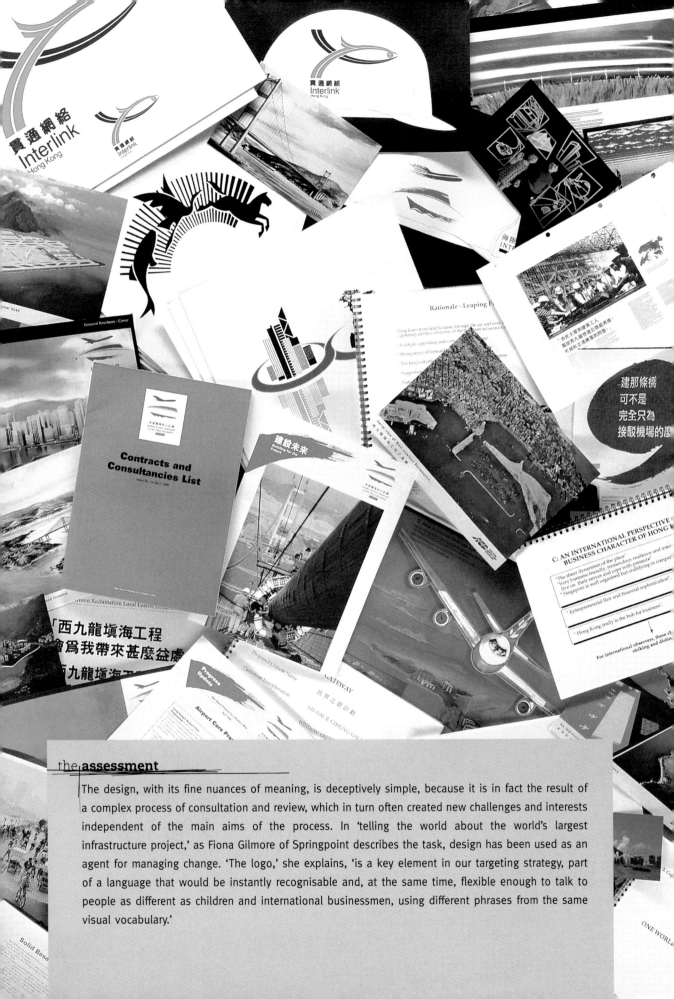

the assessment

The design, with its fine nuances of meaning, is deceptively simple, because it is in fact the result of a complex process of consultation and review, which in turn often created new challenges and interests independent of the main aims of the process. In 'telling the world about the world's largest infrastructure project,' as Fiona Gilmore of Springpoint describes the task, design has been used as an agent for managing change. 'The logo,' she explains, 'is a key element in our targeting strategy, part of a language that would be instantly recognisable and, at the same time, flexible enough to talk to people as different as children and international businessmen, using different phrases from the same visual vocabulary.'

Treading the Measure

CLIENT
Ballet-Tech
New York, USA

DESIGNERS
Pentagram
New York, USA

PRODUCT/SERVICE
Dance company

the background

Cultural organisations in the dance and theatre world have a public image and reputation which is in part a general one and in part based upon the renown of individual pieces or events. (Actors, it is said – rather unfairly – 'are only as good as their last performances.') So building an ongoing identity for such an organisation requires both firmness and flexibility, particularly where the organisation, as here, contains three individual elements that have a special relationship with each other.

In 1996 the dance impresario Eliot Feld decided to reorganise and rename his various ballet activities: previously there had been an adult troupe, which performed regularly at New York's Joyce Theater, called Feld Ballets/NY, a children's troupe, Kids Dance, and a school offering free tuition, P.S. Ballet. These were to come under the new name, Ballet Tech, and Feld approached Paula Scher at Pentagram in New York to create a visual identity for the new organisation, under which the individual components would retain their individuality but benefit from the attention that could be refocused on the organisation as a whole.

Ballet Tech begins by auditioning third- and forth-grade schoolchildren, and offers them a ballet opportunity right through to membership of a professional company.

BALLET·TECH

THE COMPANY

KIDS DANCE

NYC PUBLIC SCHOOL
FOR DANCE

the brief

The task here was to develop a logo and associated imagery for publicity and promotion for a dance company strongly involved in educational work. The combination of photography and type is particularly

the solution

The new name was chosen to balance the elegance and precision of traditional ballet and the contemporary artistry that is the hallmark of Feld's choreography. Centring around a high-energy, innovative approach to dance, the identity had to link and identify the different elements. The adult troupe was renamed The Ballet-Tech Company, and the P.S. School the NYC Public School for Dance, while Kids Dance retained the original name. The new name also linked the structure of the component elements. Each year, as they have for the last two decades, Ballet Tech offers free ballet auditions to some 35,000 children in New York City schools, and from these about 1,000 are offered free tuition at ballet classes. By sixth grade, the most talented of these children are studying dance every day at the school, as well as completing their academic programme. The Kids Dance company is drawn from children at the school, while the Ballet Tech company is now comprised entirely of dancers who have graduated from the school. Ballet Tech is thus a unique organisation, with a continuous development programme and internal links within its elements. It is not surprising that the different elements, and particularly the Kids Dance events, have become firm favourites on the New York ballet circuit.

the development

The identity comprises three related elements: typography, 'scaffolding' and photography. The type selected is a condensed Egyptian serif, used in capitals for the element names. This is printed in a deep Prussian blue where colour is used. The photographic element uses photos by Lois Greenfield of individuals or pairs of dancers as cut-out figures. These are printed as monochromes overlaid with graduated colour tones. The typographic scaffolding – designer Paula Scher's term – uses a framework of heavy rules to both isolate and link the different elements. The presentation launch logo uses the name Ballet Tech on an offset colour ground as the central element with the company names above and to the right and the strapline 'a new company from Eliot Feld' below. The main logo uses a different colour scheme (red scaffolding for blue, with the name reversed out of a blue block) and the three element names listed below. The Kids Dance logo uses red scaffolding, a blue name out of yellow and the Ballet Tech name, smaller, above in blue. These typographical elements can be laid over or around the photographic images.

The combination of typographic scaffolding and graduated photographs of dancers creates the Ballet Tech look.

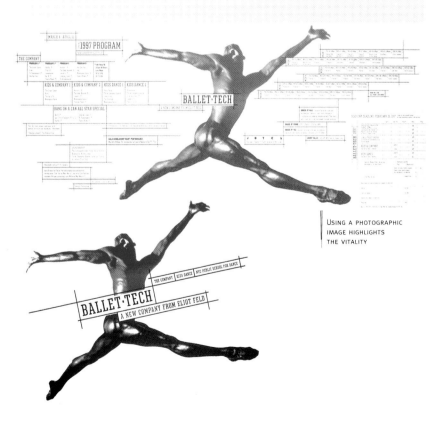

USING A PHOTOGRAPHIC
IMAGE HIGHLIGHTS
THE VITALITY

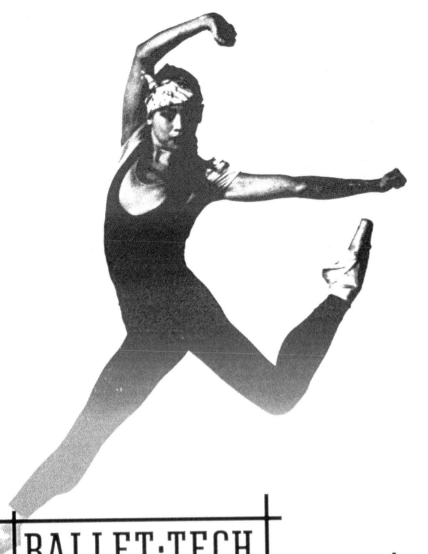

BALLET·TECH

KIDS DANCE

SEASON BEGINS AUGUST 20TH

Program A

The Grand Canon.
Ogive. Chi
Ludwig Gambits

Program B

Harbinger Clave.
With Dew Upon
 Their Feet.
The Jig Is Up.

	MON	TUES	WED	THURS	FRI	SAT MAT	SAT EVE
	8/7 A opens	8/8 A	8/9 B opens	8/10 B	8/11 A	8/12 B	8/12 A
	8/14 B	8/15 B	8/16 A	8/17 A	8/18 B	8/19 A	8/19 B

FOR TICKETS CALL JOYCECHARGE 212-242-0800

For Program Information Only, Call 212-777-7710

J O Y C E

The Joyce Theater 175 Eighth Avenue at 19th. St.

VISUAL PROMOTION IS
ESSENTIAL FOR BOTH
THE KIDS DANCE
PROJECT AND
BALLET TECH...

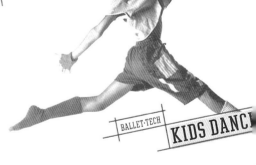

MARCH 4 - APRIL 13

BALLET·TECH

KIDS DANCE

the assessment

The result has a distinctive visual feel, but within that it has flexibility while offering the chance to exploit the opportunities and requirements of different formats, whether they be letterheads, programmes, invitations, poster campaigns, press advertising, T-shirts and even advertisements on buses. This visual language leads to the creation of a Ballet-Tech look, a consistent but varied approach that ballet enthusiasts will come to recognise and endorse. As the programme of dance events and the membership of the different companies will change over time, so-unlike the case for a corporation, the logo needs room to evolve and develop to meet new needs and opportunities, for example in incorporating images of dancers from new productions.

Achieving such variety while maintaining consistency requires both a high level of visual imagination and a clear understanding of the potential and risks of such a solution from the outset. Too tight a structure could rapidly become ossified and dated, while too free an arrangement would fail to build the links between the different companies and the schools and lose the chance to create a firm identity for this very special cultural institution in the public mind.

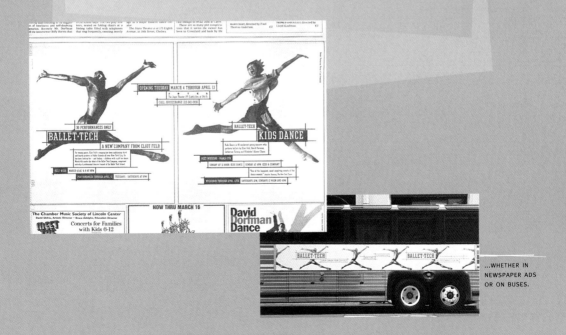

...WHETHER IN NEWSPAPER ADS OR ON BUSES.

Design from disaster

CLIENT
Düsseldorf Airport
Berlin, Germany

DESIGNERS
MetaDesign
Berlin, Germany

PRODUCT/SERVICE
Airport signage and identity

the background

At Düsseldorf airport, a fire in the main terminal building killed eighteen people in April 1996. The event, Germany's worst civilian airport disaster, sent shock-waves through the German airport system, in which most airports are run by public bodies or municipalities. After the fire the airport was being run from temporary buildings and tents, and the passenger traffic of 20,000 per day was set to rise to 70,000 when the holiday period began six weeks later, as Düsseldorf is the home airport for LTU, Germany's largest charter company. The business of an airport consists, largely, in moving people on foot from landside to airside, a process in which signage is essential for efficiency, and, even more importantly in the context, for safety. The loss of the main terminal building had left the existing signage system in collapse.

But it was not until the beginning of June that the Berlin-based designers MetaDesign were called in to advise on the signage problem. 'We realised that the deadline was very tight,' Bruno Schmidt of MetaDesign explains, 'so we accepted the brief on condition that the airport management made two people available full time with the authority to take decisions, twenty-four hours a day, everyday. This they accepted.' It was not the first hard choice the management had to make. 'German airports are run by rather formal, stiff companies,' says Schmidt, 'and Düsseldorf was in shock after the fire. They began to realise that change was going to be necessary – a more competitive attitude, for example, with the threat from Frankfurt and Amsterdam airports not so far away.' To achieve this, a new identity, not just a wayfinding system, would be needed. The project, based on MetaDesign's analysis, became within the same time-frame, not only the new signage system, but the creation of a new identity for the airport, for which the signage system would be the first element.

the**brief**

When a fire destroyed the terminal at Düsseldorf Airport there was an immediate need for new signage so that the airport could continue to function. This provided a starting point for the creation of a new

SIGNAGE POINTED
THE WAY TO THE
CREATION OF A
NEW IDENTITY

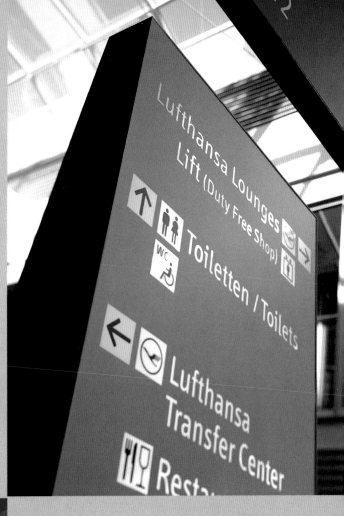

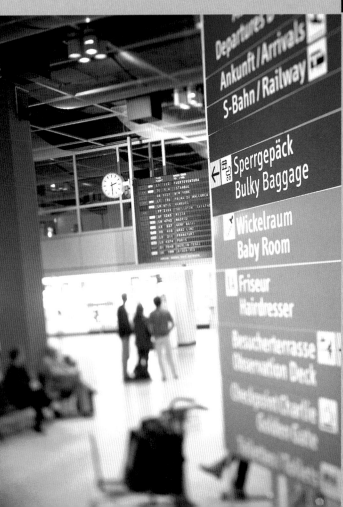

the solution

Within the six weeks MetaDesign produced a new signage programme, using a new typeface, researched to have a high degree of legibility. It also used a key colour of green under white type. 'Our research showed that most German airports had new buildings with new identities, as buildings from the 1950s had been replaced, for example at Munich and Stuttgart. We were going to have a new building, so a new signage system was needed. In selecting the typeface, legibility was the key quality we sought. As to the colour system, MetaDesign decided to abandon the previous black and yellow system, and divise a system that would also distinguish between service signage and signs specifically for arriving or departing passengers. Some colour choices were already in use as part of the identities of other airports. As to the colour, some choices were already in use by other airports – Frankfurt uses white and royal blue, Munich pale blue, Stuttgart grey. 'The green also forms a link to the colours of the local Land,' says Schmidt, 'and it forms the starting point for the development of the identity for the rebuilt airport.' The 2,500 new signs were in place in time for the holiday period, thanks to using local contractors. 'We deliberately mounted most of the signs on provisional systems such as scaffolding. This was partly because signage position would change as the buildings were rebuilt, but also to fit in with the building work going on around.' MetaDesign also developed a code for sign positioning on the master plan, so that the future development of the sign system and implementation of new signs and the identity could be handled by the airport in a flexible but correct way.

Airline I

Fluggesellschaft
Airline

Aer Lingus
Aeroflot
Aero Lloyd**
Air Alfa
Air Berlin
Air Canada
Air Europa
Air France
Air Malta

**i Informations- und Leitsystem Flughafen Düsseldorf
Piktogramme**

TAXI

Polizei

the solution

Airport signage is a mute witness to the changes taking place in the organisation, functioning and culture of airports. Successful signage programmes do not merely speed the travellers on their way, they contribute also to the total genius loci: they need to be planned to live alongside the airport's own identity, and amid the welter of other liveries, from airline colours to the retail element that is making increasing claims for attention in airport space. So the task of designing successful integrated systems becomes harder andmore challenging. Airports are waking up to the need to get signage and identity right in a different commercial world. As Bruno Schmidt wryly observes, 'profit does create change'.

COLOUR CODING FOR DIFFERENT KINDS OF INFORMATION MAKES COMMUNICATION CLEARER

Vintage enjoyment

CLIENT
Vinopolis/Wineworld
London, UK

DESIGNERS
Lewis Moberly
London, UK

PRODUCT/SERVICE
Wine vaults

the background

Feast on wine, or fast on water,	If an angel out of heaven
And your honour shall stand sure	Brings you other things to drink
God Almighty's son and daughter,	Thank him for his kind intentions
He the valiant, she the pure	Go and pour them down the sink.

So wrote the English poet G.K. Chesterton in the early years of this century in an entertaining moral fable that went on to castigate cocoa ('a cad and coward') and other drinks. The poem does not mention beer, though elsewhere beer is, in Chesterton's view, the quintessential Englishman's drink, while wine is for the French, Italians and Spaniards. Beer remained the staple alcohol of England for a long time, but recently wine drinking has become increasingly popular, partly as a result of more Britons travelling abroad, successful wine promotions in supermarkets, and a 'café culture' breaking into the dated world of the English pub.

The Vinopolis venture is a consequence of this new market for wine. Built on the south bank of the Thames in London, near the Globe Theatre, it will, when it opens in November 1998, offer an experience of wines from around the world and of the history of wine in the first visitor attraction of its kind in Britain. Housed in immense old wine vaults, Vinopolis (the City of Wine) has a suite of presentation rooms (designed by Jasper Jacob, with architects Hunter and Partners), together with a tasting hall and several multicultural restaurants. Whether such a new way of experiencing wine will succeed is, at the time of writing, too early to tell.

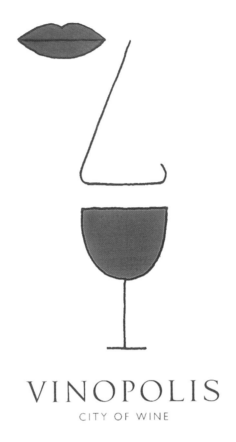

VINOPOLIS

CITY OF WINE

the brief

A new approach to the enjoyment and selling of wine, through a tourist attraction, calls for an identity that is cheerful, relaxed and immediate. The initial logo also serves as a development point for signage and packaging, so maintaining a consistency of offer across the whole activity of the new enterprise.

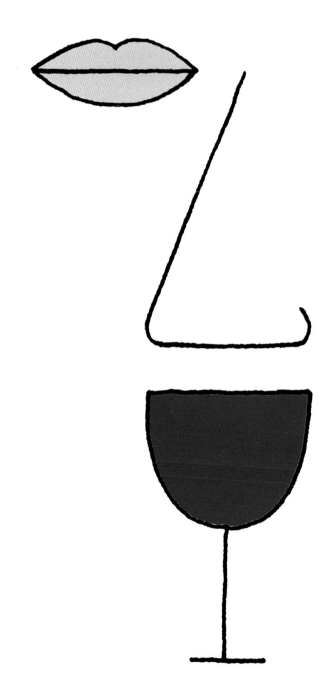

the solution

For the corporate identity the parent company, Wineworld, commissioned the London-based consultants Lewis Moberly. The brief was for a logo, stationery designs, carrier bags and wine labels for wine sales, and signage for the area. The designers' approach was based on the sensual aspects of wine: colour, bouquet and taste – the traditional tools of the winetaster. The result is a simple and very subtle logo, slightly abstract. It can be read as a vertical pattern, like a Samurai's flag: mouth, nose, wine glass. Or it can be read as a face: blue eye, profile nose, red mouth. Is the blue shape a mouth or an eye? Is the red shape a mouth or a glass?

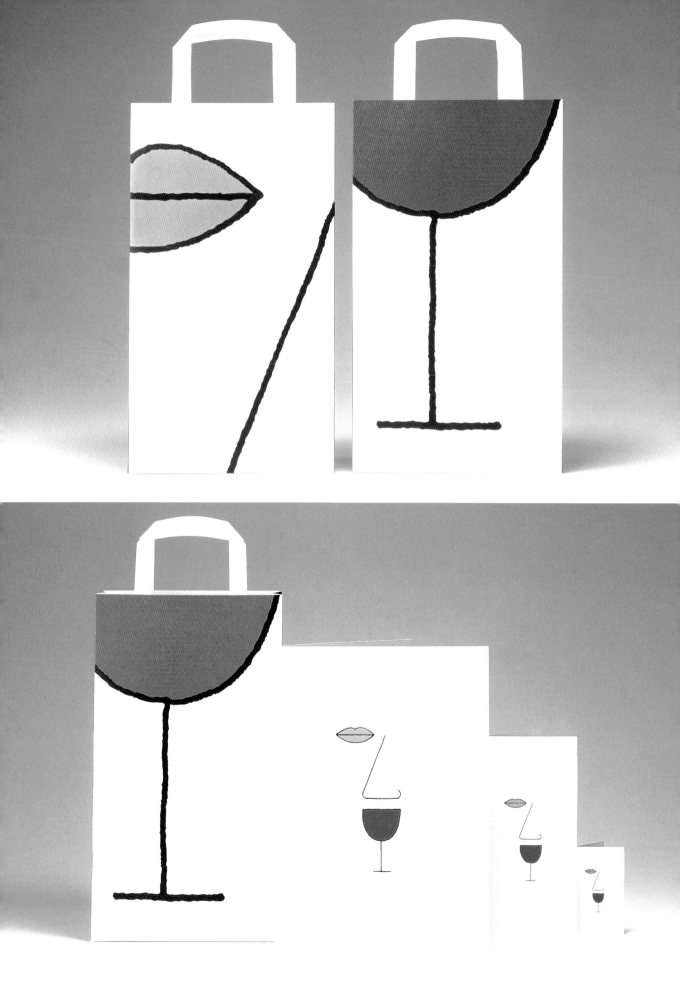

the assessment

These elements are hand drawn for the logo, and accompanied by the Vinopolis name in a classical serif face, with City of Wine beneath in sans serif. On the carrier bags elements from the design are carried over in detail, with the Vinopolis name vertically in the fold. According to design director Mary Lewis of Lewis Moberly, 'the identity simply sums up the sensual pleasure of wine. The logo is abstracted throughout, reflecting the infinite variants of the subject. Wine is now very much part of British life: we've moved on from being a beer-swilling nation.' Would Chesterton have agreed, or approved?

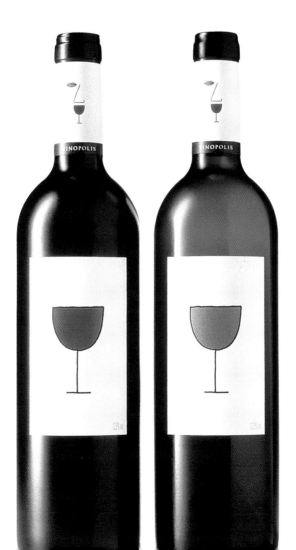

what

A brand is the visual identity of a related group of products or services from a common source.

A brand is related to the marketplace (or often a specific market) rather than the general economic activity of the company.

A brand consists of the logos, colours, names, pack shapes or slogans unique to it.

A brand may or may not contain elements derived from the corporate identity of the parent company.

is a brand ?

A brand is one of the most important design equities owned by a company. The Coca-Cola bottle is one of the most widely recognised objects in the world, though, curiously, the name of its designer is unknown. (Raymond Loewy, with his usual enthusiasm, claimed to have designed it, but in fact all his office did was modify the original shape for use in vending machines.) The name Coca-Cola is also one of the most widely recognised names in the world. How has this been achieved? The central realisation that has brought this about is, in my view, understanding that the brand is not merely the label of a product, but can also, through association, be the foundation of a lifestyle. That is to say, the product can embody aspirations and values that users of the product identify with, so in using the product they feel part of a group of like-minded people. Not only does such a successful product have a personality of its own, it expresses a way of living, a set of values, an affirmation of choices. Coca-Cola has built this personality through advertising campaigns and promotions that position the drink clearly in a relaxed, happy, youthful environment, essentially participatory and informal. Such a lifestyle is linked to a certain vision of America (another major brand, Marlboro cigarettes, uses a different vision of America in a similar way as the bedrock of its success). And having created this environment for the product, the satisfaction the product delivers must match those expectations. Achieving this kind of success requires consistency of a high order, and above all focus. Focus in the sense of continually analysing and researching the qualities and values of the product and its environment, and its mythic image. Not only does the product itself have to be absolutely right all the time, it must show an understanding of the evolving and changing environment in which it operates. This is a high-risk strategy in some ways, because if you fall from the top you go all the way down, and because diversification also becomes extremely difficult: you have to create an independent and different personality for any alternative products, since feeding them off the main one risks diluting its unique quality.

OAO

BIRDS EYE

FLEUR/CAMARADE

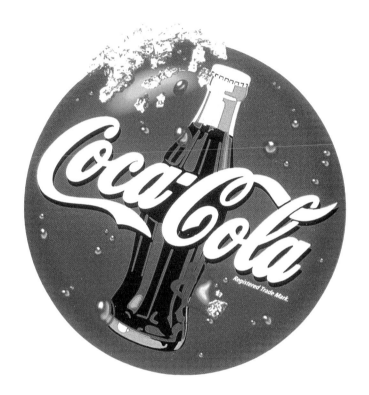

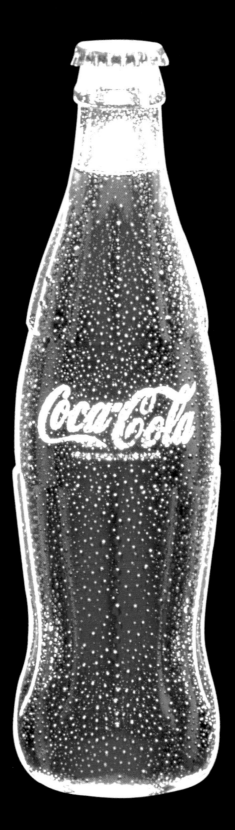

Starring Starck

CLIENT
OAO
Lima, Brussels, Belgium

DESIGNERS
Studio Starck
Issy les Moulineaux, France

PRODUCT/SERVICE
Organic and
vegetarian foods

the background

Philippe Starck is one of the most famous product and interior designers in the world. His hotel interiors at the Royalton in New York and the Mondrian in Los Angeles and elsewhere, his chairs for Kartell in Italy and XO in France, his consumer goods for Thomson and his kitchenware for Alessi, including the famous Juicy Salif lemon squeezer, have made him into a design hero. He is also now a vegetarian, and, with his usual enthusiasm, in Autumn 1998 launched himself into the world of vegetarian and organic foods. Together with the Belgian company Lima, one of the oldest and best-known producers of vegetarian products, he has created a new brand, OAO.

Starck finds that conventional attitudes to vegetarian food sometimes spring from a form of social denial, or a misplaced altruism, or a conservative, backward-looking view. He doesn't share any of these. Rather, he believes that killing to eat is, put simply, bestial and out of date. If human society is to evolve into a caring and loving society, then that is an inherited trait it has to lose. But looking at the available products and their presentation, he felt his future vision was an option that had been overlooked. It was, structurally, a marginal business, only selling to those already convinced of the vegetarian argument. What if he could recruit a new market, among younger people, who are concerned about their health, about the food industry, about the treatment of animals, but who do not share the whole of the rest of the vegetarian ethos?

the brief

The launch of a new range of organic and vegetarian foods, created by the leading designer Philippe Starck, uses an invented name and an approach to packaging that lets the customer understand immediately what is on offer. The challenge for the designer was to balance the presence of the identity

ORGANIC
MUESLI

the assessment

The OAO range is the result of this initiative, containing over 40 products, including olive oil and vinegar, salt, pepper and gomasio condiment, organic spaghetti, couscous, noodles and two types of rice. Together with biscuits, rice cakes, nuts, pasta sauces, muesli, cornflakes and oat milk, three different pâté's and two sets of instant snacks from the Biolino range by Lima, one a four-pack of breakfast mixes, the other a six-pack of lunch or evening dishes, there is also – most importantly – organic champagne and wine. This reflects the fact that the collection is not about denial, but about inclusion, about celebration not isolation.

Patrick Grandqvist, who worked with Starck on developing the branding and packaging, explains the brand concept in terms of honesty and clarity. 'Our starting point was that the customer should see exactly what is in the packet, and that the packet should contain the maximum amount of information on the organic origins and nutritional qualities of the contents.' At the same time the packaging has to have a completely contemporary look, to set it apart from other products in the field.

'Saying "you can",
not "you must":
the difference
between a
contemporary
approach which
values the

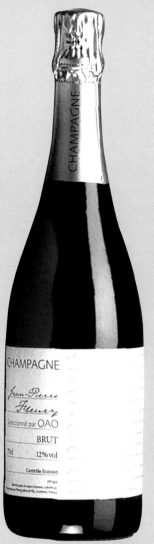

CHAMPAGNE

Jean-Pierre
Fleury
Sélectionné par OAO
BRUT
75cl 12%vol

Contrôle Ecocert

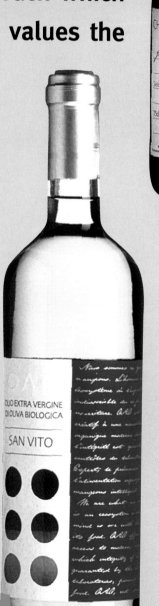

OLIO EXTRA VERGINE
DI OLIVA BIOLOGICA

SAN VITO

individual to a
conservative or
ideological
approach which
denies the
individual.'
Philippe Starck

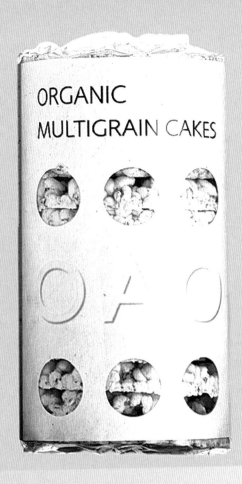

ORGANIC
MULTIGRAIN CAKES

the development

This is achieved by a basic white look, with information panels overprinted on grey or yellow. The OAO logo, in letter-spaced sans serif capitals, is printed in grey. The name OAO is an invented name, based on the Japanese word for peace, oa, not an acronym (although it could stand for Organic Agricultural Original) because the products initially sell across three languages, French, Flemish and English. The packaging materials, as a matter of principle, are recycled and biodegradable, and the choice of packaging solutions is deliberately innovative, establishing OAO as a lifestyle brand, not just a health one. So the oat milk is in a familiar Tetrapak carton but with embossed lettering (the first time this has been achieved on Tetrapak) and the instant snacks are in holders which transform into bowls: you don't have to transfer the contents to another container.

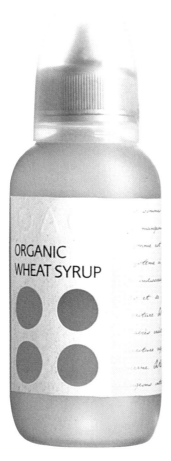

ORGANIC
WHEAT SYRUP

PRODUCT VISIBILITY IS
A KEY ELEMENT IN THE
TOTAL OFFER

the assessment

OAO represents Starck's first personal venture into branding, though he has been involved with packaging design for his products from Alessi and for electronic consumer goods as art director for Thomson. His interest in the project is as much political as personal, for he sees designers as under a social obligation to help create a fairer, less consuming, less isolated society. His view is that humanity is a species in mutation, and that designers can be the agents of evolutionary change in this process. The OAO range is one of several steps he is taking towards turning his ideas into action.

The OAO branding expertly combines a relaxed, modern lifestyle look, so reaching a new market for the products, with the obligation to honesty and openness that is innate in the underlying ethos of organic and vegetarian food. It avoids the clichés of naturalness which can so easily slip into thoughtless eco-fervour, or the parallel positioning adopted by other products in the field that suggest the customer is getting meat-free meat. OAO marks a new start, not only for Starck, but for the merchandising and branding of organic products.

Food colouring

CLIENT
Birds Eye Foods
Walton-on-Thames, UK

DESIGNERS
Springpoint
London, UK

PRODUCT/SERVICE
Frozen foods

the background

Birds Eye frozen foods are part of the Unilever group (they are marketed elsewhere in the world under different names such as Iglo). The main brand is well established, with its blue and white logo well known from packaging and from television and press advertising. The brand equity includes solid values of quality, nutrition, freshness, and convenience. – these terms were identified by the client as keys to its marketing and presentation strategy, and packaging designs for all brands are evaluated according to these criteria.

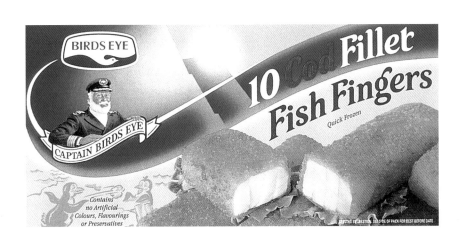

the brief

The task for the designers was to develop a purely visual language that would relate families of products under the main name. The solution is based on relating colours to taste sensations, and is a radical alternative to the normal practice of sub-brand names.

the research

Mark Pearce of Springpoint has been the designer responsible for the brand's recent development. 'Birds Eye had a number of sub-brands for different product areas such as meats and vegetables, each identified by group names,' he explains, 'but market research showed these sub-brands were not identified by consumers, either on their own or, what was worse, as part of the main Birds Eye brand.' In other words, the sub-brands were not working.

'What we set out to do was to lose the sub-brand names, which were a distraction, and instead concentrate on the main name, building a "Birds Eye world" within which there would be a range of individual offers sharing the values of the main brand but making their own statements.' This was not to be done by naming, but by visual clues linked to sensory aspects of the foods themselves: the sizzle of grilled meat, the aroma of cooked chicken, the crunch of fresh vegetables. Food is a total sensory experience, involving sight, taste and smell, with different foods evoking different perceptions (for example, research showed that chicken had different consumer perceptions from red meats, as did potatoes from other vegetables). Springpoint wanted the branding to reflect this variety and totality.

'Design is a visual language'
Mark Pearce

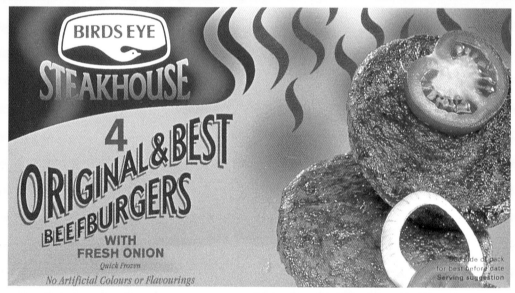

THE PACK REDESIGNS SHOW HOW
VISUAL RATHER THAN BRAND
CODING IS MORE EFFECTIVE

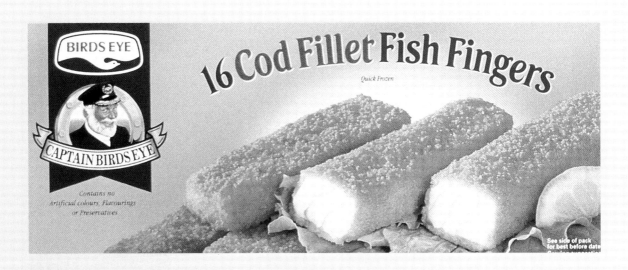

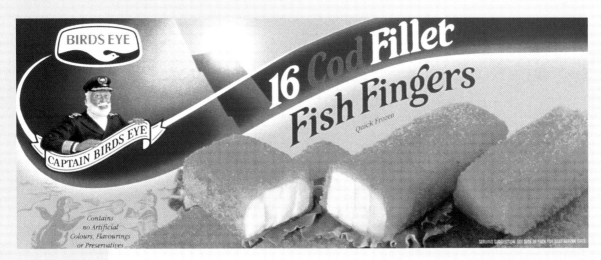

the solution

To achieve this, Springpoint created a visual map within which each of these food offers could be located, and thus linked back visually to the main logo, a system of distinctness plus proximity which can be added to as new products enter the range.

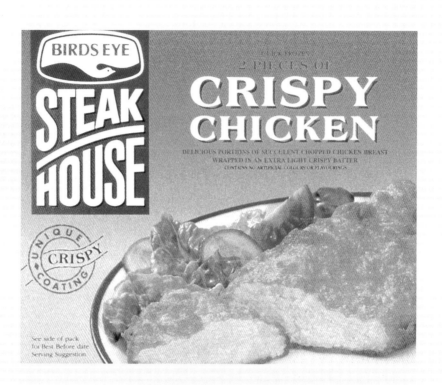

IN THE CASE OF CHICKEN
THE SIZZLE PART OF THE
COLOUR MAP IS USED ON
THE PACK

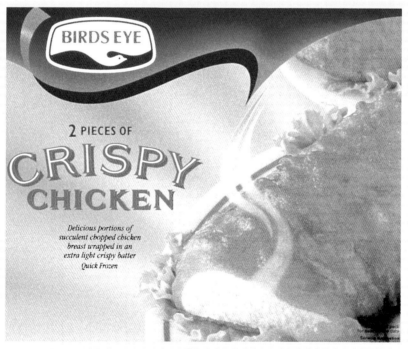

the **assessment**

Letting products develop their own visual language is also a key area in brand development.

'Design is a visual language,' Pearce insists. His skill in creating a visual metaphor for the complexities of offers and equities within the Birds Eye range is a tribute to his ability as a visual linguist, and a reminder that design success does not depend on argument but appearance (and that durable appearance has to be well argued!)

Finding friends

CLIENT
Worlds Brands
London, UK

DESIGNERS
Grey Matter
London, UK

PRODUCT/SERVICE
Cognac gift packs

the background

Fleur and Camarade are niche marketing in niche markets. Grey Matter is an established London consultancy for logo and product design (in the old terminology: they call themselves brand and product developers), working with a small group of long-term clients, including Worlds Brands, who specialise in gift products for the international duty-free market. Grey Matter recently won a Design Effectiveness Award for Fleur, a bottle of cognac for Worlds Brands. This product, for sale in duty-free shops only, is targeted at young Asian women travellers. The complete logo and branding package for Fleur was directly aimed at this narrow group.

The client was looking for ways of bringing cognac to the attention of highly specific Asian markets, starting with a women-only market with Fleur and then for males with Camarade. The packaging plus identity solution not only created successful products, but through point-of-sale material gave them a lifestyle personality appropriate to the target market.

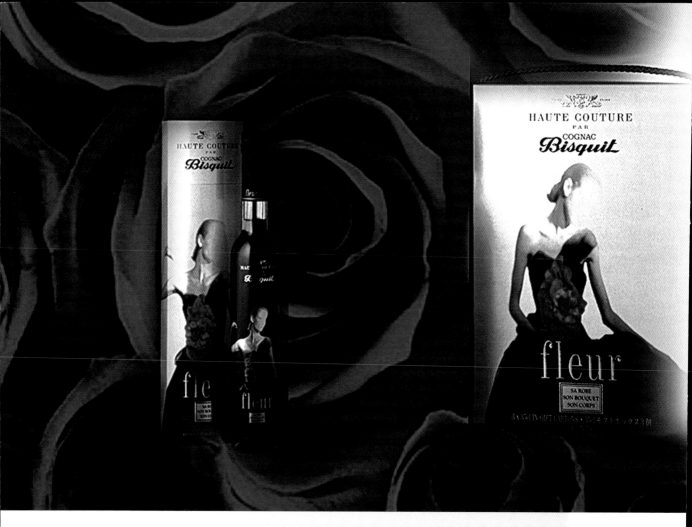

the solution

A Russian doll of niche marketing perhaps, but one only achieved through a close understanding of the client's approach and market. This holistic approach to design runs through an open office structure of 'thinking creatives and creative thinkers' and into client relations seen as teamwork not hierarchy. 'Asking a client why is always a challenge, but a necessary one for a true relationship,' Sean O'Flynn of Grey Matter points out. 'The client realised that cognac was not being bought by this part of the market, because the product was branded and presented in an inappropriate way.' So in creating the brand image of the product, Grey Matter deliberately used visual links to luxury goods, especially perfumery and sports products, with which the intended customers were familiar. And in pursuit of their view of not being compartmented, but 'compartmented plus', Fleur is not a stand-alone product but part of a future Haute Couture brand.

the development

Fleur has been joined on the same duty-free shelves by Camarade, a similar cognac for male travellers. Both products break the old rules of branding, since neither use the conventional visual language of alcohol branding. Fleur looks as if it might be a perfume or cosmetic product, with its pale cream box and floral graphics, and Camarade could be a sports or personal hygiene kit, in a green cloth and rubber container decorated with dog-tag fasteners. But both products have been very well received in their particular markets.

'We weren't trying to create a brand image that matched our expectations,' Stuart Serjent of Grey Matter explains, 'but the expectations of the target market. We looked at what young Asian travellers expected of cognac, and what they knew about it. At the top end of the market there were well-established famous names, closely linked with the culture of gifts. Below that there were less expensive brands that were purchased by experienced cognac drinkers. We were not competing with either of these. We were making an alternative offer, suggesting a personal purchase to clients unfamiliar with cognac but curious about it. To achieve this we had to put the product, through its branding, into the context of personal purchases, not gifts purchases.' So the metaphor the two brands use are perfumes and cosmetics for women, and sports goods for men. The metaphorical envelope reassures the customer that he or she is not buying something too unfamiliar.

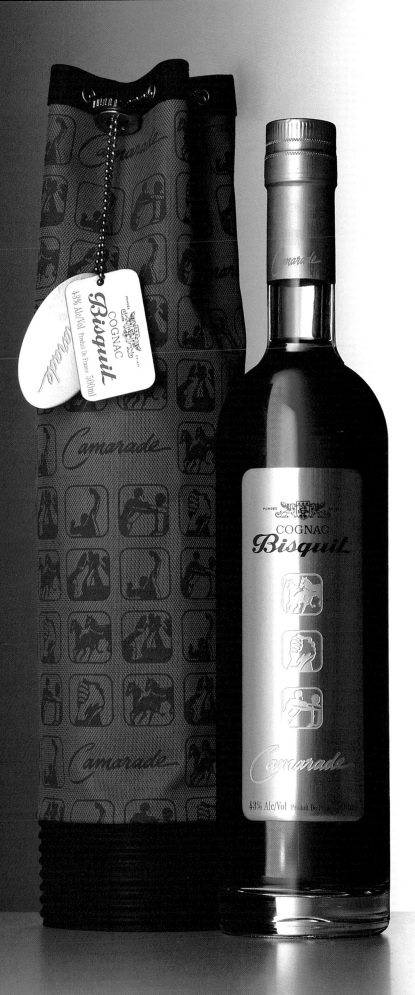

What Grey Matter achieved was to create logos that had their own lifestyle. 'For the target market Camarade had to have a Western, contemporary feel, even if it also plugs into Asian notions,' Stuart Serjent of Grey Matter explains. 'Our aim was to create a world in which the product lives, with which the customers could identify, feel one-to-one with the myths and signals generated by the product. Camarade presents cognac as a social drink, to be shared with friends. The bag is a travel accessory, as well as a giftwrap.' The point-of-sale material for the bag is a series of images of a group of young men having fun together: a bit naughty, but basically in line. Grey Matter's success with the designs for both Fleur and Camarade came from their taking a wider view, and letting the brief and its market prevail over the established concepts of how to brand products in a particular field.

'Asking a client "why" is always a challenge, but a necessary one for a true relationship'
Sean O'Flynn

what is corporate culture and brand culture?

Corporate culture is the expression of a corporate philosophy in terms of the company's relations with others internally and externally. The corporate philosophy is often set out as a 'mission statement' or 'code of practice'.

Corporate culture is not only expressed through the internal workings or commercial activity of the company: it also has an important role in external relations; for example, in the fields of generic advertising and sponsorship.

Corporate culture links the mission statements, codes of practice, marketing and development methods and corporate identity into a continuous and evolving whole. For this reason the development of a new corporate identity or the development of a revised one can often be linked to a restatement or repositioning of a corporate philosophy.

Brand culture is the same concept applied to the development and management of a brand. Brand culture may be directed more specifically at the marketplace (while corporate culture will need to take into account the company's relations with governmental agencies, international and national regulatory bodies, and the whole spectrum of public opinion).

Brand culture cannot diverge too far from the corporate culture of the parent without risking its own credibility. The degree of divergence possible depends on the perceived relation between parent and brand. Some parents are very close to their brands – Coca-Cola, for example, Kodak or Microsoft. Others are more distant – a company such as Nestlé, for example, has an own-name brand as well as a range of semi-independent brands of considerable importance. Some companies appear to operate brands at arm's length: in Europe, for example, General Motors owns a number of car marquees including Opel and Vauxhall, but keeps well in the background in terms of market presence (whatever degree of actual control they may operate over their subsidiaries). The success of a brand or corporate culture can be seen in the degree of identification between company and consumer, the extent to which the outside world trusts the company, or believes in the world its products inhabit. This relationship is a continuously changing one, which brand and identity managers need to monitor and nurture constantly. The fact that the success in question can never be exactly quantified does not mean that its existence is not essential to a company's prosperity. Some years ago Nike, the makers of sports shoes, goods and clothes, opened Nike World in New York. Unlike the Disney and Warner shops that are now found in many capitals, Nike World was not a retailing venture. It was a physical celebration of the sports-based culture that Nike has created around its products. As such, the shop displayed Nike products, showed videos of sports stars sponsored by Nike, and contained Nike advertising and promotional material, as well as games and events. Nike has used sponsorship and advertising to position its products as the equivalence of excellence. In so doing it has moved the sports shoe through fashion accessory into lifestyle necessity, while still retaining its integrity as a product for use in sport at the most demanding competitive levels. This twin track approach – excellent technology combined with desirability – is what underlies Nike's success. Motor manufacturers use a similar strategy in sponsoring motor racing, but with the drawback that the distance between the products – the Formula One car and the family sports saloon – is too wide. Not so for Nike, which has developed its position to the extent that even its tickmark logo on its own conveys the excitement and assurance of the brand.

DIRECT LINE

KLÖCKNER & CO

LEC

ESPRIT EUROPE

BRITISH AIRWAYS

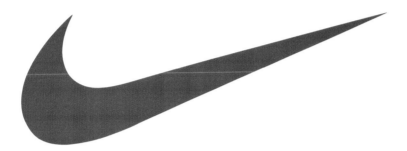

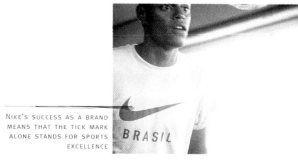

NIKE'S SUCCESS AS A BRAND
MEANS THAT THE TICK MARK
ALONE STANDS FOR SPORTS
EXCELLENCE

Invisible assets

CLIENT
Direct Line
Croydon, UK

DESIGNERS
Northcross
Edinburgh, Scotland

PRODUCT/SERVICE
Insurance and
financial services

the background

The reality of stone, bricks and mortar were the traditional visual vocabulary of banks and insurance houses. Marble halls with columnated porticos sprang up around the 19th-century world, physical symbols of the solidity, prestige and reputation of banking. Necessary symbols, because the increasing regulation of the banking industry, and the conformity of services they offered, meant there was little to choose between different bankers in terms of product or services.

The deregulation of banking and the development of credit cards and ATMs (automated teller machines) began to change that. When Citibank introduced automatic banking in New York in the mid-1980s, it went to great lengths to appear user-friendly and reassure customers that a human banker would always be available. Surveys, however, rapidly showed that customers in fact preferred dealing with the machines! A decade later the human-machine mix of banking has got considerably more sophisticated. ATMs are now situated where people spend money – in supermarkets, malls and airports – not just in the walls of banks. And within the bank building, the grills and armoured glass separating the customers from the money (and the staff) have been moved back, to create table space for meeting your personal banker. This change in space has been in response to a change in ethos.

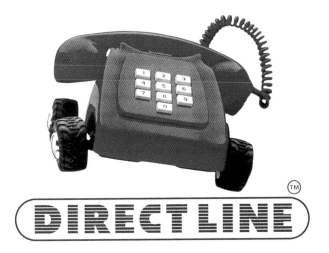

Insurance and financial services are invisible products, doubly so when sold by telephone. The designer's task was to develop a personality for the company, through its logo and through a series of promotions and publications that would make the public feel in touch with the company.

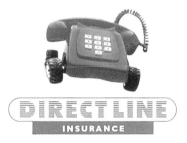

AS WELL AS
DEFINING IDENTITY
GUIDELINES THE
DESIGNERS ALSO
CREATED A
CUSTOMER
MAGAZINE,
THE ANSWER

SPONSORSHIP IS
PART OF DEVELOPING
THE BRAND, AS HERE
AT THE EASTBOURNE
LADIES TENNIS
TOURNAMENT, FOR
WHICH A HOUSE-SIZED
VERSION OF THE
LOGO WAS CREATED

the solution

If you can have a bank without a bank clerk, why not a bank without a building? That was the idea behind Direct Line, a telephone-based subsidiary of the Midland Bank initially offering motoring insurance and 'later' services such as mortgages and pensions. Direct Line's logo – a jaunty red telephone on wheels – began as an advertising image. It has been largely developed since by Edinburgh consultancy Northcross. They have created a series of exhibitions, a customer magazine, and various promotional offers. John Slater of Northcross explains: 'the marketing position of Direct Line was the people's champion. We had to create a personality around this.' This involved two major projects: the first was building a house-sized telephone as an exhibition stand, not only for indoor use at events such as the Ideal Home Exhibition, but also out of doors as a support to Direct Line's sponsorship of the Ladies' Tennis Championship in Eastbourne each year. 'Building a house in the shape of a phone is difficult enough: building one that can be taken down and put up again is another matter,' Slater comments. The second concept was Phoneham, a model town where the vehicles are red telephones. 'We wanted to entertain the customer, to put some spark and adventure into the insurance business.' Northcross's approach has been to take the bravura of the concept at its face value, and run with it.

DIRECT LINE'S TENNIS
SPONSORSHIP REACHES A
WIDER MARKET THROUGH
THE VIRTUAL TENNIS
EVENT PRESENTED AT
TRADE FAIRS

virtual
TENNIS

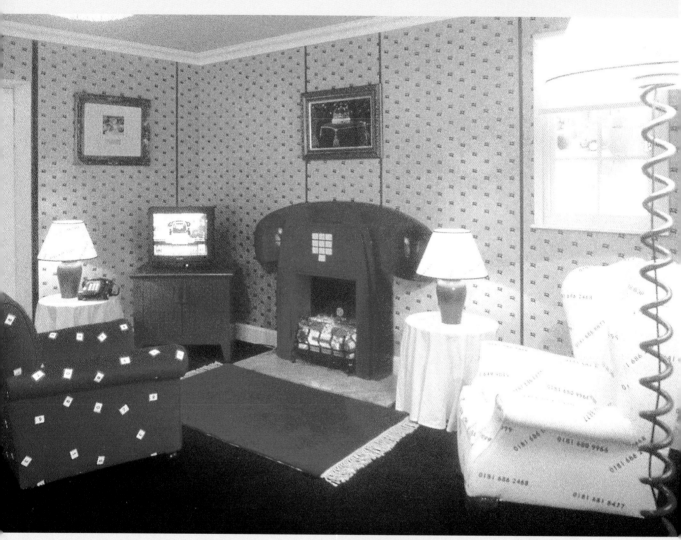

THE PHONEHOUSE LARGE SCALE
MODEL IS SHOWN AT TRADE
EXHIBITIONS, WHILE PHONEHAM
IS A PERMANENT MODEL SITE

Walking the dog

CLIENT
Klöckner & Co.
Duisberg, Germany

DESIGNERS
Wolff Olins
London, UK

PRODUCT / SERVICE
Steel stockholders
and suppliers

the background

Steel stockholders buy steel elements from mills and other producers, and sell on to construction companies and manufacturers. It is a specialised, inter-professional commodity business, where success depends on selecting likely product lines, anticipating price and supply fluctuations, and understanding the demand cycles of the different user markets. Klöckner was well established in the German market when it became part of the larger Weber industrial group in the 1980s, and from this new position the company proceeded to make a number of acquisitions in Europe (in Germany itself, France, Spain, Holland and Britain) and in the USA, a reflection of an increasingly international market for steel that was replacing national systems of supply.

klöckner & co

multi metal distribution

The challenge was to reposition a steel products group that had grown from national to international scope in a highly specialised market, and so create synergy and a common purpose between the different companies in the group. The dog motif devised for this becomes an excellent metaphor for the

the **research**

While this expansion made good business sense, the identity of Klöckner itself risked being diluted (in a business where an established name was a major advantage), not only within Weber but more widely, as there were a number of other companies called by the same or similar names in the field. In the mid-1990s the company asked the London-based agency Wolff Olins for their help. The brief also asked them to look at ways of creating more synergy between the different companies in the group, while leaving them autonomy in their own markets.

As Lee Coomber of Wolff Olins explains, 'Klöckner is operating in a closed, professional market, so the emphasis was on using any new design as an agent for internal change rather than for external perceptions.' So, for example, inventing a new name for the group would have been a retrograde step, and a waste of existing goodwill. Instead Wolff Olins devised a strategy of repositioning. 'We put it to them that they were not in the business of shifting steel, but satisfying their customers,' Coomber explains, 'or that they were in a service rather than a manufacturing business.' This strategic shift would allow top management to redirect the activities of the group in a more coherent way, with the implementation of the new identity as the start of this process.

The board of directors of Klöckner devised a new mission statement, with Wolff Olins' help. This consisted of a statement of vision and principles. The vision: to become the worldwide leader in steel and metal distribution. The principles were fourfold:
— Market leadership is our goal.
— Adding value is our competitive advantage.
— Improving our performance is our task.
— We are open, creative and consistent.

THE RUNNING DOG SYMBOL ADDS A LIGHTER TOUCH TO SPONSORSHIP PROJECTS AND INTER-COMPANY MAILINGS

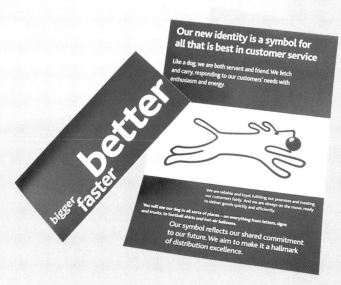

Our new identity is a symbol for all that is best in customer service

Like a dog, we are both servant and friend. We fetch and carry, responding to our customers' needs with enthusiasm and energy.

bigger **better** faster

We are reliable and loyal, fulfilling our promises and treating our customers fairly. And we are always on the move, ready to deliver goods quickly and efficiently.

You will see our dog in all sorts of places – on everything from letters, signs and trucks, to football shirts and hot-air balloons.

Our symbol reflects our shared commitment to our future. We aim to make it a hallmark of distribution excellence.

the **solution**

With this to guide them, Wolff Olins started looking for a visual metaphor for the group's activities, and for a corporate style. The ideas of service, fidelity and promptness suggested the notion of a dog retrieving a ball, and this is what Wolff Olins worked on as a visual cue. 'It had to be a simple outline, like a cartoon image,' Coomber explains, 'because it had to be light, a little naïve, and slightly whimsical at the same time. We tried lots of different images, but the version we finally chose was almost the very first sketch that we had done.' The dog, in the corporate blue with a red ball in its mouth, is used only in one pose in the finished identity, though in the presentational booklet of vision and principles it appears in a number of poses, while the red ball was used as a theme-motif in the corporate video to launch the new identity. The blue and red, together with a standard typeface, Bliss, is also set up as standard for all corporate letterheads, visiting cards, publications and signage. The red is reserved for the group name (which is always set in lowercase, and accompanied by the strapline 'multi-metal distribution'). The dog image is used sparingly, and with special attention to scale: small on stationery or business cards; large on the sides of trucks or warehouse walls, with hardly any intermediate applications. The intention is that all staff, throughout the group, will become familiar with the image and the relationship of elements to group, as will customers. 'Over time,' the design guidelines handbook explains to the group companies, 'you will become recognised through our dog as much as you are known by your own name.'

THE DOG ACTS AS A RUNNING
MOTIF THROUGH THE BOOKLET
EXPLAINING THE COMPANY'S
NEW MISSION STATEMENT

yes

Name
Function/Department

Direct Line

Direct Fax

Date

ASD plc · Valley Farm Road · Stourton · Leeds LS10 1SD

ASD plc
Valley Farm Road
Stourton
Leeds LS10 1SD

Telephone: (0113) 254 0711
Facsimile: (0113) 271 3525
Internet: http://www.asdplc.co.uk
e-mail: customer.care@asdplc.co.uk

ASD

klöckner & co multi metal distribution

Hardy-Tortuaux SA
Agence Ile de France
1, Avenue Victor-Hugo
93126 La Courneuve Cedex

Téléphone: (1) 49 34 49 34
Télécopie: (1) 49 34 49 87

Nom
Qualité/Département

Ligne directe Télécopie directe

Hardy-Tortuaux SA · 1 Avenue Victor Hugo · 93126 La Courneuve Cedex

Hardy-Tortuaux

klöckner & co multi metal distribution

Date

Name
Funktion/Abteilung

Klöckner & Co AG
Neudorfer Straße 3-5
D-47057 Duisburg

Telefon: (02 03) 307 0
Telefax: (02 03) 307 5000
Telex: 8 55 180

Klöckner & Co AG · Neudorfer Straße 3-5 · D-47057 Duisburg

Ein Unternehmen der VIAG-Gruppe

klöckner & co

multi metal distribution

Ihr Schreiben vom Ihr Zeichen Telefon-Direktwahl Telefax-Direktwahl Unser Zeichen Duisburg

Siège Social
173-179, Boulevard Félix-Faure
93537 Aubervilliers cedex

Vorsitzender des Aufsichtsrats Sitz der Gesellschaft:
Maximilian Ardelt Duisburg
Vorstand Handelsregister:
Dr. Helmut Burmester (Vorsitzender) Amtsgericht Duisburg HRB 6302
Raimund Musers
Carl-Heinrich Graf v. Fürckler
Walter v. Szczytnicki
Michael Hütten

'Marks have a life of their own,
but begin to talk to you
after a while'
Lee Coomber

THE IDENTITY GUIDELINES SPECIFY
THE CORRECT RELATIONSHIPS
BETWEEN GROUP AND CORPORATE
NAMES AND IDENTITY ELEMENTS ON
STATIONERY AND PAPERWORK

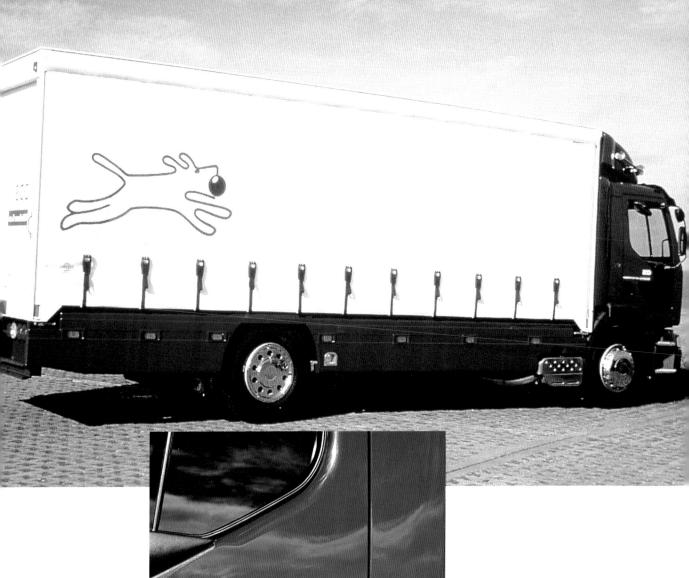

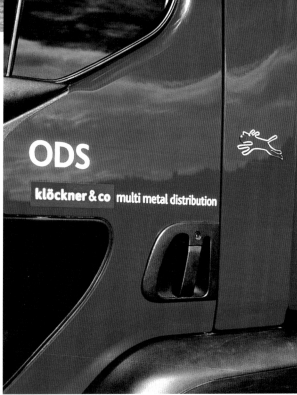

ODS

klöckner & co multi metal distribution

THE DOG IMAGE IS
USED LARGE-SCALE
ON VEHICLES AND
BUILDINGS TO
CREATE COHESION
THROUGHOUT
THE GROUP

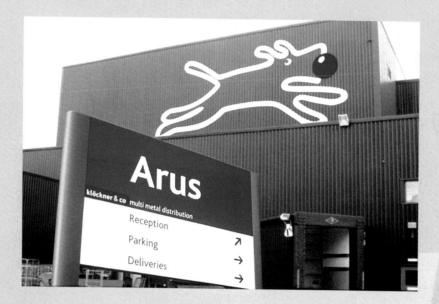

the assessment

The second phase was developing an international courier service, mainly out of London, and again HGV were invited to do the design work. Brochures and mail shots were again the main line of approach, and again the simplicity of the offer was reinforced by the directness of the design, although a blue cover was used for the brochure.

Upping the temperature

CLIENT

Lec
Bognor Regis, UK

DESIGNERS

Grey Matter Williams & Phoa
London, UK

PRODUCT/SERVICE

Refrigerator manufacturers

the background

The British refrigerator manufacturer Lec was very successful in the low-price refrigerator market when it was acquired by a Malaysian group four years ago. The new owners realised that there was an under-exploited equity in the name, especially in the export market, and asked the London-based design group Grey Matter (now Grey Matter Williams & Phoa) to advise them.

It was clear that the company's success was related to its products pricing: Lec dominated the UK market for inexpensive fridges, but even so was at the mercy of its main customers, the retail chains. To escape from this situation it was necessary to create a product and a brand that would sell on quality as well as just price. Such a change would be major, with long-term consequences. Refrigerators have working lives of twenty years, and refrigerator-making equipment a useful life of thirty years. Evaluating and planning the change carefully was a prime requirement. This was not only a manufacturing issue, it also concerned the image of the company, for if there was no perceived continuity between the older and new product ranges, the products would risk failing. For example, a company making breakfast cereals could easily diversify into tea and coffee, but would find it harder moving into packet soups or frozen vegetables, because the equity values in the company would be relevant to one but not the other.

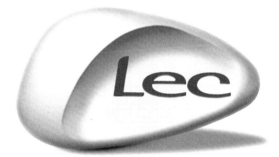

the brief

The client's decision to move its product range upmarket not only involved developing a new logo, but a redefined corporate culture to make the change work right through the organisation. This was achieved by an analysis of the associations and territory of the product offer.

the research

To enable Lec to assess their current values and to see how to move forward, Grey Matter used a system of their own devising called TABS. Imagine a square divided into four equal squares by a horizontal and vertical line. Sean O'Flynn of Grey Matter explains: 'Above the horizontal is the macrocosm; below the microcosm – or, if you prefer, the world above and the product below. The top left square stands for territory, the top right is A, for associations. Bottom left is B, for base delivery, bottom right S for satisfaction. The product of the brand – and in this case and many others they are indissoluble – has to fit into each category in ways which relate to each other completely and coherently.' O'Flynn cites a major brand such as Coca-Cola or Malboro. Malboro defines its territory and the associations very clearly: open space, freedom, the American way. This is supported by the base delivery on the pack, the mountain shape, the primary colours and the typography. And the satisfaction of this territory: the kind of smoke, the taste and bite of the cigarette, is unique to Marlboro and reinforces the expectations created by the territory and its associations.

The TABS system has three advantages. Firstly it provides in-house a complete model for approaching a brand or identity design of any kind. Secondly it provides a way of analysing the design process and solution with the client, in terms that are not design-specific. 'With some clients,' Stuart Serjent of Grey Matter explains, 'we explain the TABS concept at the start and apply it together. In others we work from the results. We are not asking the client "what do you want your logo to look like?"; we are asking "what sort of company do you want to be?" The first is not the kind of question they can often answer anyway, while the second is central to the company's approach to its products and its markets.' The third advantage of TABS is that the results it produces can be tested objectively, either during the design process or at the end. And because the system has such a broad base, it can be used as a vehicle for wider changes in the company, not just to get a new brand or image.

In the case of Lec, the territory of the refrigerator can be described in shorthand as the kitchen, with its associated values of food and family, and also there are the specific associations of the refrigerator with freshness and safety. But there was an immediate difference between the design of fridges – white, square metal boxes with applied badges in gold or silver – and the ideal kitchen. Most of the fitted kitchens sold in the UK were country-style kitchens in plain or varnished pine: a contradiction to the white box, though the white box also signified purity and safety. So the challenge was to move the white box closer to the ideal kitchen, without sacrificing its existing, valid associations. The existing associations could be termed strength, reliability, safety and taste, and in creating the brand image these needed to be extended to embrace sensuality and pleasure. 'Our aim was to make people say "I love my fridge",' as Sean O'Flynn puts it. In marketing terms, such a change could be seen as consumers deciding positively on the basis of preference, not negatively on the basis of price, so moving Lec away from its dependence on price alone as a market factor.

If the base delivery had to be a more sensual shape, how was satisfaction to be defined in terms of a refrigerator? Basically a fridge is a container: what it delivers is the condition of its contents. Fresh, clean, crisp, cool: the descriptors are all sensory terms. These qualities had to be built into the branding as well as into the product.

THE NEW IDENTITY WAS NOT JUST A MARK BUT A DEFINITION OF A NEW SET OF PRODUCT VALUES

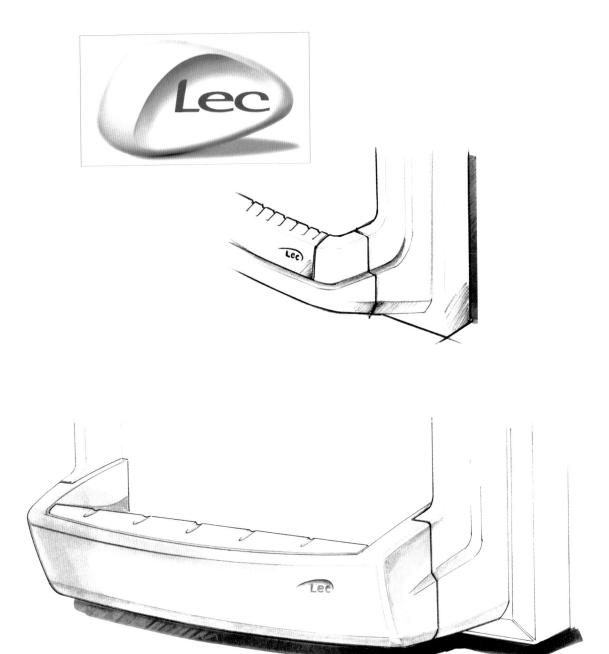

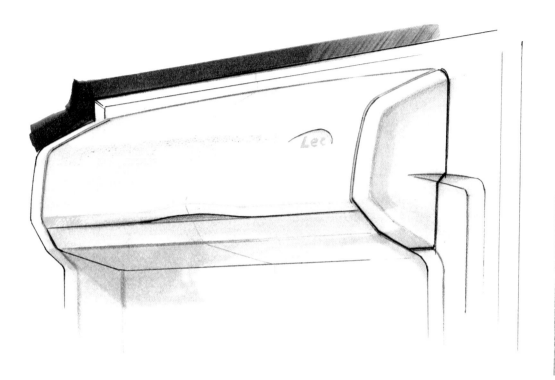

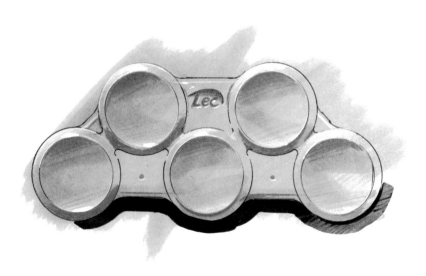

Design drawings helped
integrate the identity into
the product rather than
only applying it

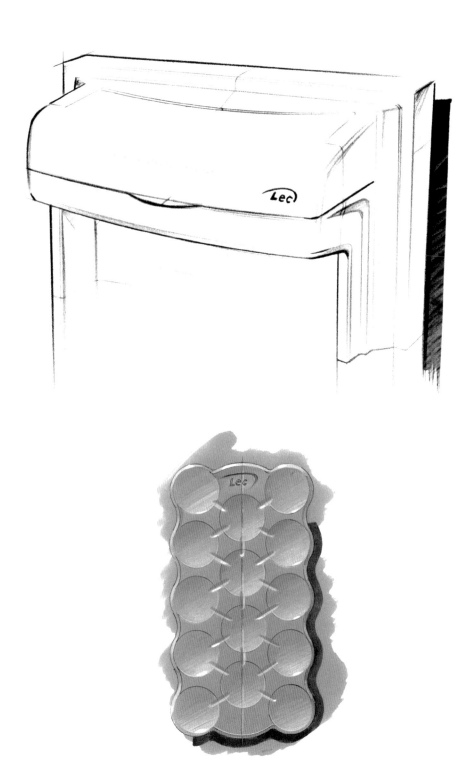

the solution

As a logo, Grey Matter evolved what they call a pebble, a sculpted asymmetrical shape engraved with the letters Lec in green sloping type. A pebble, because a pebble is natural, solid and sensual. The white colour echoed the concept of purity, the green a consciousness of the natural world. Engraved lettering because the marque is integral, not applied. This final logic is taken a step further: while the pebble marque is used on labelling, letterheads, literature and advertising, it does not appear on the fridge itself. Because, as Serjent points out, 'the pebble is not on the fridge because the fridge is also the pebble.' The brand and the product fuse into one entity. The values of the brand are the values of the product are the values of the company. And in rebuilding the brand around the new product range, Grey Matter also rebuilt the company, since the strategies for marketing and presenting a new product and a new image had to be different. 'Change can be aspirational as well as necessary,' as O'Flynn points out.

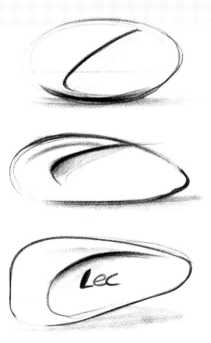

THROUGH THE TOTAL INTEGRATION OF THE LOGO THE PRODUCT ITSELF BECOMES THE BRAND

MOOD IMAGES WERE AN
IMPORTANT PART OF THE
PROCESS OF EDUCATING
MANAGEMENT ABOUT THE
COMPANY'S NEW VALUES

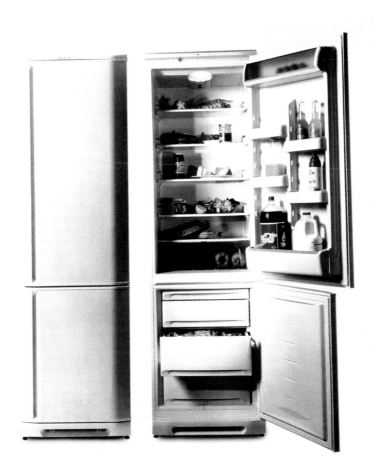

**'We didn't redesign the logo,
we redesigned the company'**
Sean O'Flynn

the assessment

If one measure of success is the reaction of the competition, it seems that Lec got it right. A year after they introduced their new range of sculpted white refrigerators, their competitors presented new rounded shapes or coloured finishes. But if the analysis Grey Matter has done is correct, Lec will ride out the competition, since the tabs system goes beyond the immediate design brief into a range of wider issues, and so consolidates the design solution not just as a temporary visual fix or an elegant aesthetic device, but as a tool with a logic that runs into the raison d'être of the client company itself. Grey Matter is unusual among design companies, in developing and using such a formal model: others arrive at similar conclusions by experience or intuition. But Grey Matter has accepted the necessity for design companies to work alongside its clients, and see the design result as part of a wider strategy for the company.

Good moves

CLIENT
Esprit Europe
London, UK

DESIGNERS
HGV
London, UK

PRODUCT / SERVICE
Courier services

the background

The Eurostar high-speed rail service links London to Paris and Brussels through the Channel Tunnel. With up to ten trains a day to and from each destination, the service offers a comfortable and rapid city centre to city centre passenger service. But as the trains also have some freight capacity, the parent company, London and Continental Railways, decided to add a courier service, using the trains to offer, initially, a same-day or overnight delivery between the three capital cities. Three design companies were invited to make a non-creative pitch for both naming the company and designing its identity, which was won by the London-based group HGV.

esprit *europe*

the**brief**

The initial brief was for an identity for a courier service using the high-speed train link under the English Channel. With the success of the first venture, the brief was extended to a wider range of services, through a series of related promotional brochures and packages.

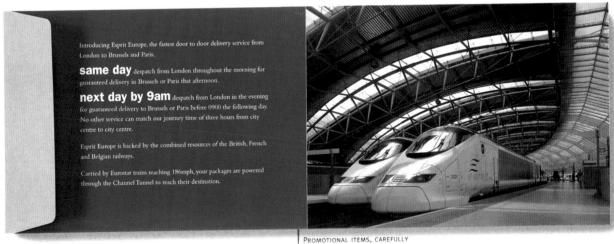

Introducing Esprit Europe, the fastest door to door delivery service from London to Brussels and Paris.

same day despatch from London throughout the morning for guaranteed delivery in Brussels or Paris that afternoon.

next day by 9am despatch from London in the evening for guaranteed delivery to Brussels or Paris before 0900 the following day. No other service can match our journey time of three hours from city centre to city centre.

Esprit Europe is backed by the combined resources of the British, French and Belgian railways.

Carried by Eurostar trains reaching 186mph, your packages are powered through the Channel Tunnel to reach their destination.

PROMOTIONAL ITEMS, CAREFULLY TARGETED, WERE ESSENTIAL TO DEVELOPING AWARENESS OF THE SERVICES OFFERED

the solution

The first task was the name: here there were two main factors emerging from the brief. The name had to be comprehensible across the three languages, and contain the European concept. Esprit Europe achieved this: the words read in all three languages (English, French and Flemish), and the assonances of the term echo those of Eurostar. The logo, too, was influenced by the Eurostar connection: an outline parcel with a sloping front (to echo the distinctive streamline of the Eurostar locomotive), a touch repeated in the italic sans serif lower-case lettering of the name.

the development

But Esprit was, at first, a courier company only serving three cities, while competing with the likes of UPS, Fedex and DHL. Esprit had the advantage of offering a same day service, but certainly there was no budget for television or other broadband advertising. Instead, HGV devised a series of carefully targeted mail shots, using simple brochures printed with brown paper covers, like parcels. The delivery vans were also painted brown with mock labels on the side panels. Clients would find a copy of that day's Le Figaro newspaper from Paris waiting on their desk in the morning (Le Monde, the other French paper of record, is published in the afternoon) with a brown paper wrapper with the Esprit logo and the words 'News Travels Fast'. Or a packet of Belgian chocolates labelled 'Fast Food'.

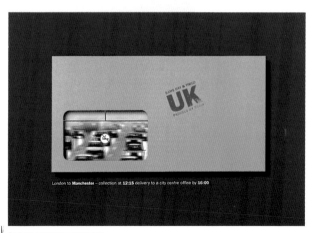

As new services developed,
new presentations
were needed

'The colour and material on its own was saying "Esprit" in the same way that pink newspaper says Financial Times.'
Pierre Vermier

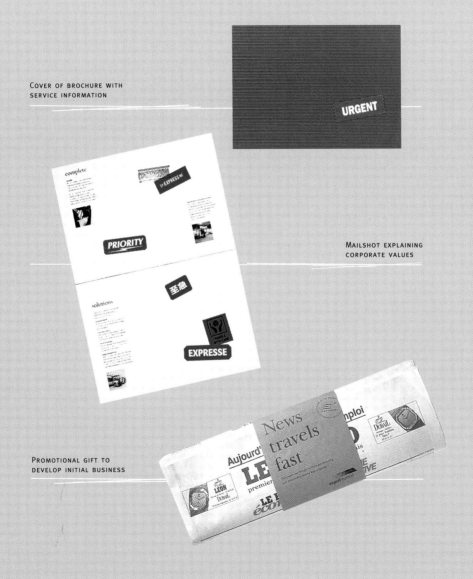

COVER OF BROCHURE WITH
SERVICE INFORMATION

MAILSHOT EXPLAINING
CORPORATE VALUES

PROMOTIONAL GIFT TO
DEVELOP INITIAL BUSINESS

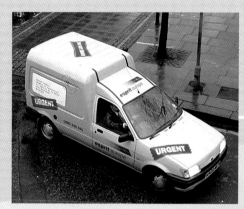

VEHICLE LIVERY AND
ADVERTISING MAINTAINED
THE ORIGINAL BROWN PAPER
PARCEL PROPOSITION

A response rate of up to ten per cent on a mailing shot is generally considered average. Esprit was getting take-up rates of over 80 per cent. The design and marketing mix was perfect. From the design standpoint, the proposition was a simple one: 'this is what Esprit can do – same day to Paris and Brussels; this is how – using Eurostar; these are the times and charges.' This information was elegantly but simply set out, in a no-nonsense way. Esprit built its business from nothing in 1995 to a turnover of £400,000 in just five months.

The second phase was developing an international courier service, mainly out of London, and again HGV was invited to do the design work. Brochures and mail shots were again the main line of approach, and again the simplicity of the offer was reinforced by the directness of the design, and although a blue cover was used for the brochure the continuity was maintained (and the formality of the pages reduced) by using white on red 'urgent' or 'priority' stickers as in the original brochures and mailshots. When it came to the third phase, extending the service across the United Kingdom, HGV realised that the parcel motif had, in the customers' eyes, become an integral part of the logo. Therefore it went back to the brown paper approach for the brochure for the UK service.

the assessment

The different developments of Esprit were unexpected: HGV thought it would bow out after the initial set-up, but in fact has stayed involved fairly continuously for four years. This is partly due to the success of the business, but that success was in part achieved through developing initially a design proposal that was sufficiently direct and well crafted to reach its target market, and robust enough to provide a design platform for the subsequent development of the business.

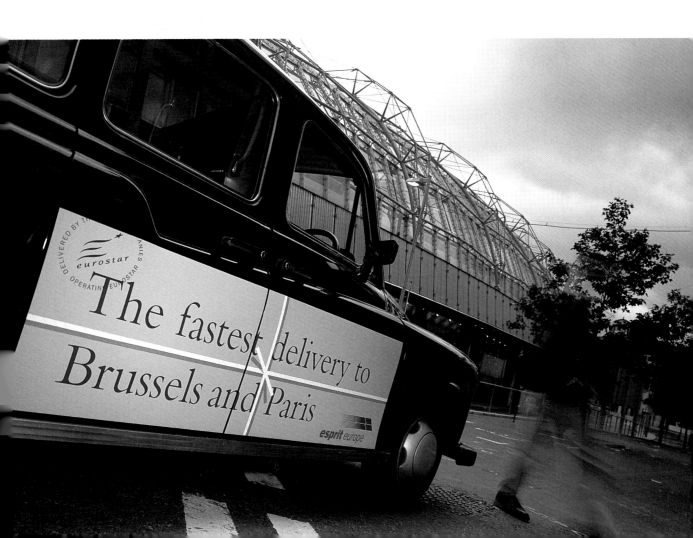

Flying the World, not Flying the Flag

C L I E N T
British Airways
London, UK

D E S I G N E R S
Newell & Sorrell
London, UK

P R O D U C T / S E R V I C E
Airline

the background

The idea of aircraft as flag carriers dates in part from the early history of commercial aviation, when sea transport was the nearest form of international trade that could provide an organisational model, and in part from the last days of empires, when countries needed a secure means of transport for diplomats and officials, and for mail services. With the need to rebuild commercial airline services in Europe after the Second World War, many airlines became nationalised, and so identified with the country of origin and ownership. British Airways was created by the merger in the 1970s of the pre-war British Overseas Airways Corporation and British European Airways. Both had established identities; BEA's built around its successful 'We Fly the Flag' advertising strapline, BOAC's on its Speedbird logo, dating from 1938. But times change, and perceptions change. The airline is now a publicly quoted corporation, and was looking to redefine its position in a changing commercial environment.

The standard approach to a national airline identity is to link it strongly with national elements: Alitalia uses the green red and white of the Italian flag, KLM a crown motif as a reminder that the Netherlands is a monarchy (the KLM translates as Royal Dutch Airline), Air Canada a maple leaf. And the normal practice is to use the chosen motif with a maximum of consistency in order to reinforce its message. According to this view, any distraction from the corporate statement is a dilution of its efficiency.

BRITISH AIRWAYS

The design of a new identity for one of the world's largest airlines was based on four years of research and preparation, and breaks with traditional identity rules to create a bold global image based not on a single logo but a series of related designs from around the world, together with a softer approach to the treatment of the corporate name, so positioning British Airways as 'global and caring', the main tenets of the brief.

the research

The detailed logic behind the decision to redesign the corporate identity stems from a major investigation launched by British Airways in 1994, to study the future development of the airline, and to understand and analyse public perceptions of it, nationally and internationally, and among passengers and non-passengers. The case for a new identity emerged from this process, which defined British Airways as being 'global and caring'. What this superficially simple phase meant was that British Airways was a diverse community of people based in Britain, providing a service to the communities of the world. It did not mean putting Britain or Britons first; it was not about dominating the airways; it was not about power and success except in terms of having the ability to satisfy the needs of the customers. There is a deliberate contrast here with other airlines whose offers are either based on some skewed notion of supremacy or of exclusivity, or authority. Nor is it a populist or somehow downmarket position. The opposite is dictatorial, after all – is not weak but democratic.

The new British Airways World Images logo/branding unveiled in June 1997 was the result of two years' close collaboration between BA's design management department, headed by Chris Holt, and their selected designers Interbrand Newell & Sorrell. The new identity, as far as the treatment of the name is concerned, comprises a softer typographical style, a new Speedmarque ribbon logo, and a colour scheme closer to Britain's traditional red, white and blue. To this is added a series of images representing the creative work of different peoples and places. For Interbrand Newell & Sorrell took the global concept not in a simply geographical and political sense but as a network of communities who are served by the airline. From this concept of patterns the idea of World Images was born. As John Sorrell points out, 'World Images is not about only identifying BA as the national flag carrier. Our task was to position BA as a world brand, the equivalent of Coke or Microsoft, but one which is based and has its roots in Britain.'

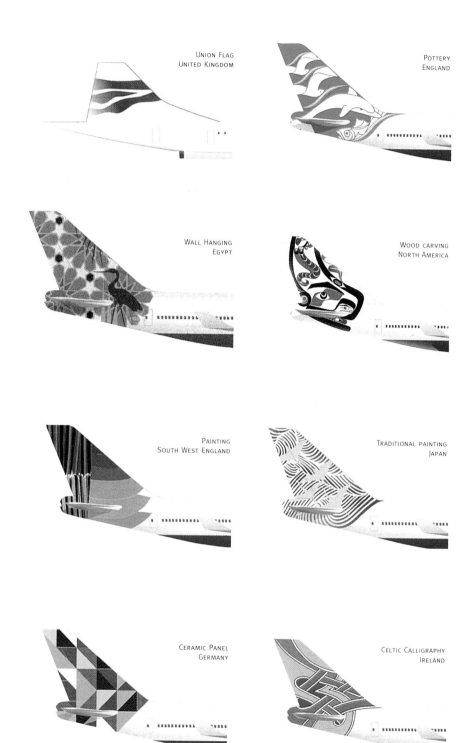

UNION FLAG
UNITED KINGDOM

POTTERY
ENGLAND

WALL HANGING
EGYPT

WOOD CARVING
NORTH AMERICA

PAINTING
SOUTH WEST ENGLAND

TRADITIONAL PAINTING
JAPAN

CERAMIC PANEL
GERMANY

CELTIC CALLIGRAPHY
IRELAND

SEVEN JACKALS
UNDER TREES IN
THE KALAHARI
PAINTED BY
CGOISE

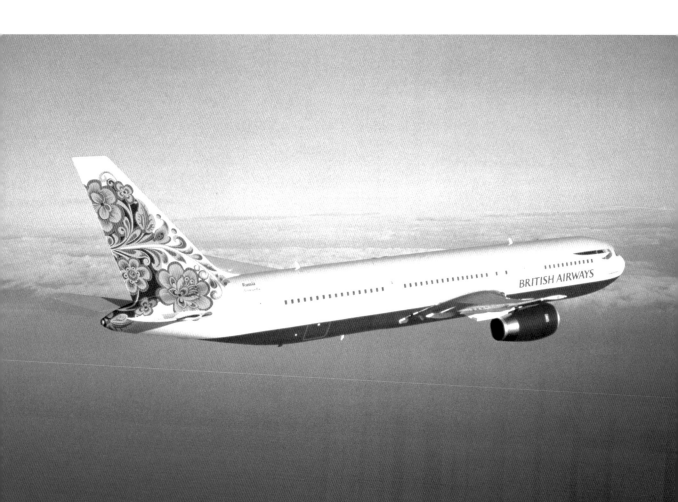

the **solution**

The largest identity surface, the 60-foot-high tailfin of a Boeing 747, is not given over to a single logo or image but to a selected image among the 33 'World Images', abstract or semi-abstract patterns created by living artists whose work represents continuity between creative, real and active communities (ignoring national boundaries, be it said). When the roll-out of the identity is complete in the year 2000, each aircraft in the BA fleet will have one of the World Images on its tailfin, and the images will also be used on business cards, corporate publications and documents: more images, with time, will be added to the repertory. Neither will that work by a Dutch artist be seen only on the Schipol/Heathrow route. Ideally the planespotters of Amsterdam are going to see a series of different World Images, from Japan or India, St Ives or Nairobi.

The selection process that led to the choice of Interbrand Newell & Sorrell was a complex one: one consultancy was used to assess potential candidates worldwide, a second one made a blind approach to a first list of 40, asking for a credentials presentation, and only then did BA invite a final shortlist of four design teams to make an initial, paid presentation. As Chris Holt says 'we chose Interbrand Newell & Sorrell on the basis of their skills and their vision. We developed the World Images idea from an element in their presentation to us, but which was part of the background briefing, not a formal proposal, originally inspired by the idea of world patterns made by humankind throughout our evolution.'

The concept of serving a global community is reinforced by a collection of images called 'People Photography', which showed the ordinary citizens of the world in their communities. It gave a human context to the World Image series, and so underpinned the new identity. The 'People Photography' images are used in direct marketing, promotions and other below-the-line applications. Extending an identity in this way shows how closely related the launch of a new identity needs to be with the marketing and overall presentation of a company's services. It creates an added depth to the image of the company, and strengthens the perception of the company culture, thus enabling the transition to a 'world brand' as suggested by John Sorrell.

CONTEMPORARY CELTIC
ILLUMINATION BY IRISH
ARTIST TIMOTHY O'NEILL

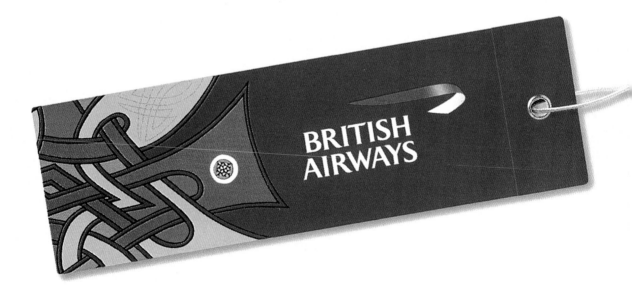

MODERN SCOTTISH
TARTAN WOVEN BY
PETER MACDONALD

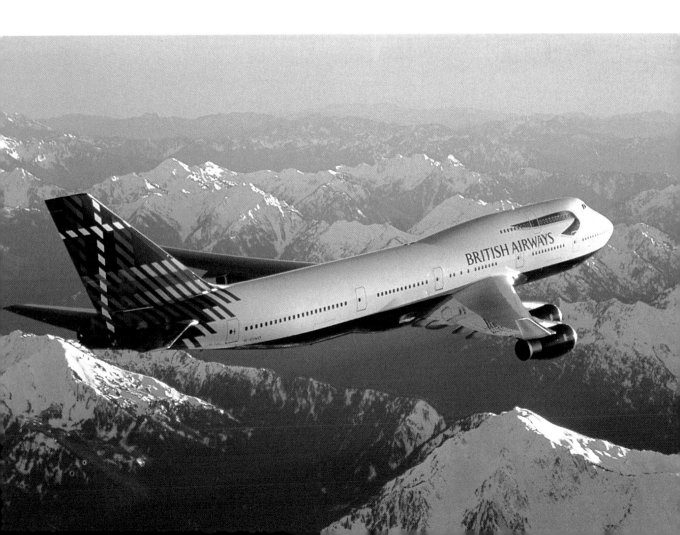

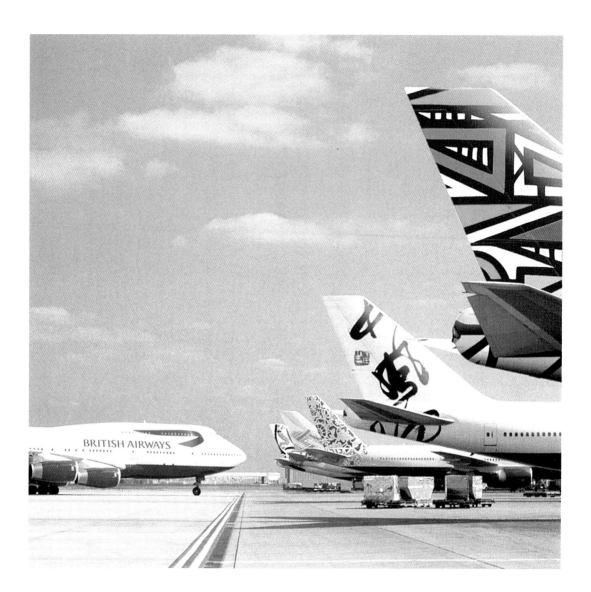

the assessment

Because of its technical complexities, airline corporate identities have tended to be the preserve of a small group of companies with established track records. The fact that Interbrand Newell & Sorrell was a newcomer worked to its advantage, in that more experienced designers might have rejected some of its ideas before starting to develop them. Putting a design on an aircraft's tailfin, for example, involves painting individual colours through masks made by hand, complex enough in itself, but it has also to be integrated into the servicing schedule of the aircraft.

When BOAC introduced Indian stewardesses to its long-haul routes in the 1950s, it made haste to explain to the travelling public that Norman Hartnell (fashion designer to HM the Queen) had been consulted over the choice of clothing colours. Since then, BA (as it became) has grown, and grown up. Its decision to state its international role so boldly sends a message to designers everywhere looking at what have traditionally been seen as national brands. They are perhaps missing a much larger and very important point.

To my mind the success of the World Images concept is not only that it defines a global activity through concepts of communities rather than concepts of nationality, nor is it that it avoids the clichés of much corporate identity work with such elegance. The subtlety of the solution lies in pairing the series of images with their endlessly different cultural resonances, with the relaxed yet ordered Speedmarque, name and colours. And the pleasure in it stems from the variety. For many people flying today is a matter of routine: any sense of excitement or adventure flying may have once had has been worn down by sameness and repetition. World Images shifts that forgotten perception back into focus. The sight of an exotic design on the tailfin as you are waiting in the departure lounge to board is a gentle reminder that you can actually go wherever you want. And the next time you take the same business flight to the same destination, there will be a different image waiting for you.

The four key elements

Logos, corp
tit

the conclusion

What is the role of the designer? If the logo is the base element in the corporate or brand identity, and the corporate or brand identity the base element in the corporate or brand culture, then clearly the way to approach the design or redesign of a logo, identity or brand is from the top down. Understanding the corporate culture first will give the necessary framework to even the most specific brief, and help define possible solutions later, as well as excluding inappropriate options at an early stage. The overriding question to put to the client is therefore 'what sort of company do you want your company to be?'

In approaching the task in this way, it becomes clear that researching the brief is of primary importance, whether this research is conducted through formal market research methods or a design audit or through informal discussions with the client and others. Such discussions can be visually based, as with the TABS system used by Grey Matter, described on page 122, but their normal goal is to establish a vocabulary or just a list of key terms, that describe the company's values and aspirations. The value of such an approach, for the directors and managers of a company, is that it enables them to follow and understand the design process from a familiar standpoint, rather than considering visual options for which they may have no wider context, apart from personal preference.

brands,

Once this research period is well under way, then the designer's visual skills have something to work on. A successful design will be the visual expression of the corporate or brand values uncovered by the research. It has often been said that good design delivers a solution beyond the client's expectations. The real truth in this is that good design is based on a clear understanding of the client's expectations and ambitions, and visually presents a solution that the client could not have devised or imagined alone.

When Hutchison Telecommunications decided to launch a mobile phone network in the UK, they asked Wolff Olins to advise them on both the identity and the name for the service. There were already two established networks in the UK, and mobile phone usage was beginning to 'trickle down' from business use to private use. Wolff Olins' research confirmed that mobile phone usage was set to spread rapidly, and suggested that the positioning of the existing companies was based on the concept of the mobile phone as new technology. But the new market of private users would not be interested in the technology, just in the service, and so to base the new offer on technology would be neither relevant nor original. In fact Wolff Olins went a step further, and envisaged the mobile phone as becoming, in a short time, as common a piece of personal equipment as a Walkman or an electronic bank card. In other words, it needed to be presented as a lifestyle object, not just in terms of communication or technics. They therefore chose the name Orange for the company, and developed guidelines for presenting the corporate image that were based on the use of mobile phones not as exclusive or complex, but as absolutely straightforward and contemporary. The name deliberately had no associations with the telephone business (which was a useful feature in a teaser advertising campaign before the product launch).

The result of Wolff Olins' understanding of the changing perception of mobile phones (from yuppie toys to everyday objects) made Orange an immediate and continuing success, despite its apparently arbitrary nature and its apparent failure to play by the rules and position itself within the established mobile phone market. In fact, its success came from putting itself outside that market, but into the future marketplace for the product.

'**Designers should read about everything except design**'
Philippe Starck

Editor
Chris Foges

Letterheads & Business Cards

Introduction
Johannes Baptiste de Taxis was looking for a way to
make some money, and hit upon the idea of unifying
Europe's postal routes and running them as a
commercial operation. In 1519, Holy Roman Emperor
Maximillian 1 made him Postmaster General, and a
new communication age was born. However, the date
doesn't mark the birth of letter writing, or for that matter
letterheads. Letter writing dates from pre-history, and
the use of a unique piece of design on which to write
them is not much younger: even trade cards – a fore-
runner of the business card – pre-date the Postmaster
General; one of the earliest known examples is for a
hatter in Paris and dates from around 1470.

Before Maximillian's creation of a unified postal system, written correspondence in Europe was mainly between kings, diplomats and the like, and confined to national or international politics, although by the 15th century the growth of trade between commercial towns had led to an increase in written communications on what might loosely be described as prototype letterheads. By the 17th and 18th centuries, however, merchants and trade guilds had their own letterheads, similar to those of today in many respects, and notable principally for their ornate decorative splendour.

It was not for another hundred years, though, that the post, and with it the letterhead, became central to business as well as personal communications. In 1840, Sir Rowland Hill introduced a flat charge of one penny for any letter sent anywhere within Britain. The new postal charges were immediately taken advantage of by groups such as the Anti Corn Law League, who recognised a new and effective way to disseminate propaganda. Today, a wide variety of organisations including big corporations, small businesses and private individuals still use the letter as one of their most effective and direct forms of communication.

Even in the age of the fax and e-mail, the UK's Royal Mail still deals with nearly forty million business letters a day, while the US Postal Service has grown significantly since Benjamin Franklin was made its first Postmaster General in 1775: it now delivers hundreds of millions of items every day to eight million businesses and 250 million Americans. The letter has some particular and distinctive design qualities that give it an edge over other forms of communication: receiving a letter is a visual treat with colour, images and typography working harmoniously. It is a sensuous experience – most letters are printed on high-quality stocks; they are folded and inserted into envelopes giving the impression of substance and three-dimensionality. Put together in stages, signed and sent, the letter gives a feeling of permanence and credibility that other forms of communication do not have. As a punning advertising slogan for the UK's Royal Mail has it, 'People respond to a letter'.

Letterhead for the Bauhaus,
designed by Laszlo Moholy-Nagy,
1923. From the collection of
Elaine Lustig Cohen

Letterhead designed by and
for El Lissitzky, 1924. From the
collection of Elaine Lustig Cohen

Detail from letterhead for
Oskar Rüegg, designed by
Anton Stankowski, 1932. From the
collection of Elaine Lustig Cohen

162 163

The designer's role

The graphic designer, as we understand the term today,
only became involved with letterhead design in the
1920s. Printed letterheads engraved with a seal or
symbol became common by the 18th century, and by
the 19th century business stationery had developed
significantly, although its design was still in the hands
of printers, who would customise designs for clients
from a range of ready-made alphabets and images from
catalogues. Many carried an illustration of the firm's
physical assets – its factory or offices - as a graphic
boast. These letterheads, while attractive and functional,
were essentially formulaic, and thus a different
proposition from that offered by independent design
consultants throughout the 20th century. That
notwithstanding, many printers continue to offer the
service of letterhead design – several hundred even
offer a complete service through the Internet, where the
relevant information is taken on-line and formatted
electronically into pre-existing templates.

Screengrabs from the site of
Labries, a printer offering
letterheads and business cards
on the Web

But at the turn of the century, the growth in advertising and packaging brought with it a recognition that all of the visual communications material issued by a company were representative of it, and each should be considered on its own merits. This catalysed a change in the approach to letterhead design, and we begin to see the basics of branding, or what is now referred to as corporate identity, on printed stationery: that is to say, the use of a group of typefaces, a selection of colours and images, and a logo. By the 1920s, freelance design consultants were regularly designing letterheads and business cards for clients, and the design of stationery, often as part of a larger corporate identity programme, had become economically important to the design industry.

Also active in the 1920s was Jan Tschichold, a young German designer who was influenced by the teachings of Walter Gropius and the Bauhaus school, and showed how the ideas put forward there could work in the area of communications, rather than architecture and furniture design.

The graphic design work being done by members of the European Avant Garde in art such as El Lissitzky, Herbert Bayer and Kurt Schwitters was 'formalised' in Tschichold's 1928 book, 'Die Neue Typographie' ('The New Typography'), in which he laid out the modernist rationale for design. In a chapter devoted to business forms, Tschichold presented the letterhead as a working piece of information design, in which its various components played an active role in synchrony with the contents of the letter itself, as opposed to performing a largely decorative role. Tschichold's theorising on letterheads was set in the context of an increasingly industrialised, business-led society. Modernist designers debated the role and function of design in the context of industry, and rejected the old 'artistic' designs as being out of step with the character of the world they were working in. While some of his orthodoxies regarding absolutes and standards were later challenged, Tschichold's basic assertion that the role of the designer in design for business was the clear and effective communication of information holds true today.

Corporate identity

This emphasis on standards and uniformity also fed into the concurrently growing practice of corporate identity making – the idea that a company or organisation must have a strong and coherent visual identity to act as an expression of its 'personality'. This had been on companies' – and designers' – agendas since the turn of the century. In 1907, the architect Peter Behrens was commissioned to overhaul the visual identity, communications and even buildings of the German electrical firm AEG, in what is widely reckoned to be the first major corporate identity job.

At its most basic, a corporate identity is achieved through the design of a mark or logo, by which the company and its products might be recognised. This mark can then be applied, in a controlled way, to all of the company's communications – its brochures, its advertising, its packaging and, of course, its stationery.

A company has a variety of audiences, and it also has a variety of things it wants to tell them – sometimes individually, sometimes collectively. For collective communication, a company might advertise or create a brochure. For individual communications on a wide variety of topics, however, the basic 'big three' of stationery systems – the letterhead, business card and compliments slip – are suitable for most purposes. The company will probably also have at its disposal other branded communication tools, designed in synchrony with the letterhead: the envelope or gummed envelope label, the fax header, the invoice, the credit note, the order confirmation, sticky labels for floppy disks, CD-ROMs, video cassettes – the family of letterhead relations continues to grow. (Meanwhile, other items of stationery decline in importance: as more records are kept on computer, fewer rolodex-compatible business cards are required, for example. Similarly, visiting cards, as distinct from business cards, have largely disappeared in the last fifty years.)

The ways in which the items in a company's 'communications tool kit' are used are dictated by an identity manual produced by the designer – a set of guidelines which ensure that each item works in the way that it was intended. The letterhead section of an identity manual, for example, should tell the user where on the sheet to put the recipient's address, how far down the sheet to start typing, how far in from the left-hand side, and where to stop on the right. In some cases it might contain stylistic recommendations such as whether to use numerals or words for numbers, how to write dates and percentages, or even how to sign a letter. The following extract from an identity manual produced in the 1960s for British Rail by Design Research Unit shows the level of detail included in some manuals. 'Where there is room, leave six spaces for the written signature and then type the name of the sender with his or her designation on the line below. The designation is not necessary where it is printed at the head of the paper. Name and designation may be omitted where the letter is informal.'

Selection of business cards
designed by the Japanese design
consultancy Azone & Associates

166 167

Form and function

As a communications tool for a company or individual, the letterhead has three basic functions: primarily, of course, it is a means to convey a message. Secondarily, it clearly presents a small amount of useful information concerning that company, and the information contained within the letter: who it came from, where it came from, how it relates to other correspondence and so on. The Japanese designer Takenobu Igarashi has suggested that the clear presentation of such information may explain why the Japanese attach great importance to the exchange of business cards at the start of a meeting: the Japanese language uses over 7,000 symbols, the most common being Kanji, which can be hard to differentiate as many words with identical pronunciations may have very different meanings, so that one can only be sure of understanding something correctly when it is seen written down.

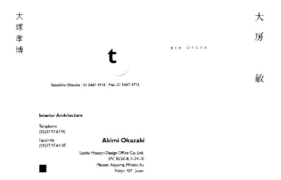

大塚孝博

t

Takahiro Otsuka | 03 5467 4710 | Fax. 03 5467 4712

Interior Architecture
Telephone
(03)37.97.67.90
Facsimile
(03)37.97.64.05

Akimi Okazaki
Soichi Mizutani Design Office Co. Ltd.
3FC BOX-8, 4-24-10
Minami Aoyama, Minato-ku
Tokyo 107 Japan

BIN OFUSA

大房敏

The letterhead or business card may well also give some form of professional provenance: it is common for those with professional qualifications to include them on letterheads and business cards. Furthermore, in the UK for example, it is a legal requirement that the letterhead carry a certain amount of information relating to the ownership, location and status of the company: the registered office of any limited company must be shown, as must the directors of any company registered under the 1916 Companies Act.

More rules exist for sole traders working under their own names, more for those working under other names, and yet more still for invoices or credit slips.

In addition a company might want to describe its business – even if it is just to say 'architect' or 'accountant'. A subtler, less literal description of the business is often achieved through the use of illustration – from the company's own mark to a specially created design that tells the reader something more about the 'personality' of the company – perhaps that it is fun to work with; that it is successful; that it is forward looking. In this respect, it is only in degrees of sophistication that letterheads have changed at all since the status symbols of the last century.

Instruction sheet from
Jan Tschichold's Typografische
Entwurfstechnik (1932). The folded
transparent vellum sheet shows
a practical example overlaid with
DIN guidelines

The rules of letterhead design
As has been described, there are certain elements which
all letterheads share, and others that are unique to each
company or individual. The designer's job is to combine
them in a way that is of greatest benefit to their client.
A conflict does exist between the standard and the
unique. The market, and human nature, value the
unique and bespoke: they attract attention and give
pleasure to the mind and the eye. Yet, on the other
hand, design thinkers from Eric Gill to the Bauhaus
school have argued that where the designer is working
for industry, he should adopt its qualities of precision,
utility and rationality, and work to a set of standards
recognised and accepted by all.

While there are no rules apart from those enshrined
in law, as described earlier, there are standards and
precedents. No law says that a letterhead must be a
particular size or shape, but a set of precedents and
nationally recognised standards means that most are.
The Japanese letterhead usually measures 21 x 26
centimetres; the American is eight and a half by eleven
inches. The Europeans use the Deutsche Industrie
Normen (or DIN) system, devised in Germany in the
early 1920s. The European letterhead size A4 – which at
297 x 210 millimetres is the 476 Standard – refers to this
system, which was later adopted by the International
Standards Organisation in Switzerland. Business cards
are A7 in the DIN system, or 105 x 74 millimetres, while
envelope sizes are covered by the C series.

The DIN (now ISO) standard
measurements: A7 is half the size
of A6, which is half the size of A5
and so on. A4 is the standard
European letterhead size

The designers of the DIN system are often referred to as architects, perhaps out of respect for the mathematical simplicity, yet bold brilliance of their creation.

The ratio of the lengths of the size of any DIN paper size is one : the square root of two, meaning that however many times the paper is folded, the ratio remains the same. In his translation of Jan Tschichold's 'The New Typography', the design writer Ruari McLean makes the point that DIN's roots as a system for architects and engineers was a great part of its appeal for modernist designers such as Tschichold: it puts the less technical, more arbitrary practice of graphic design on the same formal footing as three-dimensional, engineering-based design.

While designers are free to disregard national standards, they should only do so after some thought: paper is now produced in standard sizes, and deviating from that may create the need for a bespoke sheet. Similarly, most of today's companies use software and hardware set up by the manufacturer to anticipate standards, from the word processing package to the desktop printer. Again, deviation from the norm can result in expense and time wasting.

Various influential designers and movements have argued about what belongs on the face of a letterhead, in what form, and in what place. Designers associated with the Bauhaus rejected all illustration except for simple geometrical shapes in primary colours. In 'The New Typography', Jan Tschichold proposed such standards as the use of asymmetric layouts, sans serif type and a wide left-hand margin. The British designer Herbert Spencer, in his book 'Design for Business Printing' (1952), argued that there were two sorts of printing – utility and promotional. As conveyors of information rather than advertisements, letterheads fall into the former category and should therefore be designed with clarity in mind. Furthermore, Spencer observed that letterheads should be easy to file and retrieve, recommending that information which would help these processes be placed on the right-hand side of the sheet. It is up to the individual designer, in the knowledge of the requirements of their client and the circumstances of their time, whether they pay any heed to these suggestions, but precedent is a powerful force and in most letterheads produced today, the influence of history is clear.

CJS Plants business card,
illustration printed on both front
and reverse faces, designed by
The Partners

170 171

The challenge of the new
Letterhead design used to fall into the category of what
was known as 'jobbing printing'. The name says about
it what many people still believe: that in design terms
letterheads are by definition formulaic and dull. On the
first point, as FHK Henrion wrote in 1967, "the visual
coordination of stationery is easy to begin, and very
hard to finish". To which one might reply with a quote
from another design great, Java pioneer Ed Frank:
"I think there are two types of people in this world –
people who can start things and people who can finish
things. And while I place great value on the finishers,
it's the starters who are rare because they can envision
what isn't there."

Charles Short

CJS Plants
Avery Hill Nursery
Avery Hill Park
Bexley Road
London SE9 2PG
Tel 081-850 1110
Fax 081-850 2110
Mobile Phone
0860 335417

The European designers of the avant garde, present at the birth of graphic and typographic design as a discipline in its own right, certainly envisioned what wasn't there and shaped the way we think about design and its function even today. And they used the humble letterhead to communicate new and revolutionary ideas about design, proving that far from being formulaic, the letterhead is an ideal breeding ground for innovation and experiment. Letters sent between the leading practitioners in Poland, France, Germany, Holland and the US carried on their faces the living evidence of a shift in design thinking. The flow of letters not only spread the influence of these schools of thought, but helped define their development.

Letterheads for the various movements of the time such as the Bauhaus school, and others which were not even physical entities such as Futurism, Constructivism and Dadaism, were the primary means of communicating and recording the significant changes taking place in the ways that designers were approaching visual communication. What those designers showed was that as well as being a test of skill, letterhead design can also be bold, beautiful and significant. It is up to the designer today, with the tools at his disposal – the choice of materials, form, printing and surface effects, illustration and typography – to carry on that tradition of graphic innovation.

A bespoke watermark in a letterhead sheet, created by Arjo Wiggins Fine Papers

Plastic business card for and by multimedia design studio AMX

Plastic business card in the style of a credit card, for use at a John Galliano fashion show. Design by Area

Metal business card designed and produced by the Graphic Metal Company

Business card designed by and for Sagmeister Inc. The letter 'S' is revealed when the card sits fully inside its transparent sheath

Materials

As Ernst Lehner noted in his book 'The History of the Letterhead', paper is a relative newcomer to the game of letter writing. Although the first sheet was made in China in about 200 BC, there was a time when it was not viable to send letters on paper, and communications were sent on Sumerian bricks, Assyrian and Babylonian clay tablets, Egyptian papyrus, Greek sheepskin, Roman wax tablets and a myriad of other devices. It goes without saying, of course, that today's letterheads and business cards will almost invariably be printed on paper of one sort or another. But even within paper, there is an almost infinite variety available to the designer: uncoated papers, coated papers, translucent papers, coloured stocks, hand-made papers and a host of others offer an enormous variety of choice, the making of which is a fundamental part of the design process. Some materials lend themselves better than others to certain printing processes or special effects, but for letterheads the designer is by no means restricted to what are known as office papers.

There are also positive client benefits to be had from the right choice of stock, beyond an impressive look and feel to the letterhead: for an order of a few thousand sheets and upwards, a bespoke stock is a very real option, economically. A sheet containing a bespoke watermark, or other security features such as microfibres embedded in the paper, can provide the client with a degree of security.

Business card for the book
publisher Faber & Faber. Design
by Frost Design

Business card designed by and
for the Conran Design Group. The
card comes inside a metal folder
which also carries a mini-portfolio
of the company's work

Form

Graphic design is often wrongly thought of as two-dimensional design: on closer inspection, however, it is obvious that books, magazines, brochures and indeed letterheads operate in three dimensions – even the most basic letterhead is designed to be folded. Although, typically, a letter is in the DIN A4 size (in the UK and Europe) or US Letter size in the US, is read portrait and is one unbroken sheet of paper with squared-off corners and neat cuts at the sides, the designer is able to change the format of the letter in a number of ways: through cutting, folding and changing the shape and size of the sheet.

This might be done to accommodate a particular type of information, or to allow the card/letterhead to be used for a dual purpose – or merely to make it more memorable, or to raise a smile from the reader.

While the standard fold into thirds allows the designer to feel sure that the address will end up in the right place for use with window envelopes, for example, using an alternative folding pattern can add life and a sense of functionality to a letterhead. It can act as a visual descriptor of the company's business, as in HGV's letterhead for James Sutherland Construction (pages 34–35), or be witty and amusing, as in The Partners' visually punning letterhead for Silk Purse (pages 42-43).

National standards notwithstanding, designers are also free to experiment with paper shape. As the pioneering Japanese designer Shigeo Fukada wrote in 'Letterheads of the World' (1977), 'letterhead paper shape should not have to be square to perform its function. It is not necessary to think about extreme cases like roundness or triangles, but I wish, by all means to use letter paper of parallelogram or rhomboid [shape].'

Business card for Pascal Wüest,
a photographer. The address
is applied with a rubber stamp.
Design by Wild & Frey

Letterhead for Richard Foster.
The company name is embossed
down the side of the sheet.
Design by Lippa Pearce

Letterhead and business card for
Random Bus. The company's
name is reflected in illustrations
across the stationery system
which show a 'random' selection
of views of a bus. Design by
Sagmeister Inc.

Surface effects
From the days of engraved trade cards, stationery
designers have added character and a feeling of quality
to the letterhead or business card with surface effects
through printing techniques and treatments such as
embossing, debossing, foils, varnishes and laminations.

Most letterheads are now litho printed but techniques
such as letterpress, which was invented in the 1400s
and was still the most prevalent in the 1920s and '30s,
can create stunning effects. It is a distinctly 'low tech'
approach but, like the rubber-stamped letterhead
produced by Wild & Frey (below left), it has a certain
charm and, in many instances, budgetary advantages.
Some printers, such as Artomatic, whose own stationery
system is featured later in this book, specialise in
unusual print techniques or in printing on unusual
materials. Even run-of-the-mill printers, however, should
be able to cope with techniques such as embossing or
foil blocking, which lend a sense of quality and distinction
to a business card or letterhead.

Illustration
Since the earliest recorded examples in the 15th
century, letterheads have carried illustrations of one sort
or another. And while the type of illustration is dictated
by contemporary fashions and the limitations of printing
processes, generally speaking they are an integral
feature of the letterhead.

Here again, the options open to the designer are
numerous: at its most basic, the letterhead will probably
carry a company logo, but after that, the designer may
use hand-rendered illustration, photography, typographic
illustration or ideograms containing pertinent slogans
or messages.

Even in instances where it is desirable to leave as much
white space as possible on the face of the letterhead,
as current design aesthetics suggest in cases where
formality is a consideration, there is still an equal
amount of space on the reverse face which can be used
to carry further 'information' about the company in the
shape of illustration.

Letterhead for Celcius Films with the address printed on the reverse of the sheet. Design by Carlos Segura of Segura Inc.

Letterhead for Martin Bax, the editor of a poetry journal. Designed by Alan Kitching of the Typography Workshop and printed letterpress

Compliments slip for Planit Events, an event planning organisation. The date on which the letter was sent is shown by pushing out one of the scored circles at the top of the sheet. Design by Carnegie Orr

176 177

Typography

As design is concerned with the conveyance of information, the design of letterheads is a fundamentally typographic exercise, and one in which the real thought begins after the selection of an appropriate typeface. At its most basic, the job entails sorting information into hierarchies according to the way in which they will be used. For that purpose, Jan Tschichold recommended asymmetrical layouts. Herbert Spencer concurred: 'Asymmetrical layout is flexible. It allows a precise and delicate control of space in which emphasis is achieved by disposition rather than by weight or size.'

In 'The New Typography', Tschichold described the component parts of the DIN standard letterhead: the recipient's address on the left (as once it has served its original purpose, it does not need to be seen in a filing system); space for receipt and treatment marks on the right; the four main pieces of information – your ref., your letter of, our ref. and the date – in one horizontal line under the headings; the firm's particulars; a left side margin of at least twenty millimetres. He also made the point that a single letter is part of a multiplicity – a correspondence – and that 'without order, such a multiplicity becomes unmanageable'.

While other designers have chosen to group information differently, or even to dispense with convention altogether, the basics hold true: essentially the design must strike a balance between effective communication and looking good. Writing in 'The New Typography', Jan Tschichold included an aside which, when one reads between the lines, sums up everything the approach to designing letterheads today should be: 'In general, the typography of the old letterheads took no notice of the fact that the letter as received should be written, signed and folded. Only when it is a completed whole can it look beautiful!'

The international
Society of Typographic Designers

std

Studio 12
10–11 Archer Street
Soho
London W1V 7HG
United Kingdom

T 44 (0) 171 734 6925
F 44 (0) 171 734 2607

Co chair
Freda Sack

Postcard and business card for
Alice Twemlow, a writer, curator
and lecturer specialising in visual
communication. As most of
Twemlow's communications are
through phone, fax or e-mail, she
does not require a complete
stationery system in the traditional
sense. Design by Martin Perrin

The future
Writing in Berlin in 1926, the artist and designer El Lissitzky
foretold the death of letter writing. 'Correspondence
grows, the number of letters increased, the amount of
paper written on and materials used up swells, the
telephone call relieves the strain. Then comes further
growth of the communication network...then radio eases
the burden. The amount of material used is decreasing.'
Well, neither the telegraph, nor the radio, nor the
telephone, nor the fax has ever completely obviated the
need for letterheads – probably thanks to its unique
characteristics, as described earlier.

MESSAGE>>

ALICE TWEMLOW
VISUAL CULTURE
TEL/FAX : +212 206 0236
ADDRESS : 11 ABINGDON SQUARE 2F
 NEW YORK NEW YORK 10014
E-MAIL : TWEMLOW@AOL.COM
UK : TEL/FAX +[0]1491 638591

ALICE TWEMLOW
VISUAL CULTURE
TEL/FAX : +212 206 0236
ADDRESS : 11 ABINGDON SQUARE 2F
 NEW YORK NEW YORK 10014
E-MAIL : TWEMLOW@AOL.COM
UK : TEL/FAX +[0]1491 638591

However, the booming volume of personal
communications in the digital age will inevitably, in time,
pose a new set of problems for the designer. In a world
where global markets mean that face-to-face meetings
are increasingly replaced by video conferences, what
will take the place of the exchange of business cards?
New York's Duffy Design, for one, has recently
produced an interactive business card for itself. As the
Web continues to grow at an exponential rate – and
already it has grown from fewer than 300 computers
on-line world-wide in 1981 to over 90 million in 1997 –
more and more commercial transactions will be made
between individuals at their PCs and a Web site.

Furthermore, as e-mail continues to gain ground on
paper memos internally and letters externally, its users
may want to transfer some of the sophistication of the
letterhead to that new medium. US-based design group
io360, for example, is among the pioneers in beginning
to consider the future of the e-mail interface, in terms of
matching style and structure with content (see below).

The present
So that's the past, and that's the future. The rest of this
book is concerned with the present. This book is not
intended to be an instruction manual; nor is it a history,
or an awards annual. But in the following pages there
are a wide variety of stationery systems designed by
some of the best designers currently in practice,
which I hope will inspire readers to look again at the
letterhead, and re-evaluate its potential for good design.
Whether they are rigid Swiss-schoolers or free-form
deconstructionists, the common denominators between
the designers of all of the stationery systems shown
here are an eye for detail, a painstaking care with the
raw materials of design and a wealth of original ideas.

180–205
Shape/Size/Fold

35 Little Russell Street
London WC1A 2HH

-44 (0)171 637 1231

-44 (0)171 636 5015

-44 (0)171 637 7068

Client
Kinos Aarou

Design company
Wild & Frey

Brief
In a world driven by the profit motive, the Zürich cinema Kinos Aarou is an outsider. It selects what films it will show on the basis of depth and cinematic quality rather than high box office takes or explosive content. As a result it shows a diverse mix of mainstream Hollywood blockbuster movies, classics, art house films, ciné noir and anything else that makes the grade. When it commissioned Wild & Frey to create a logo and stationery, the cinema emphasised that the design should reflect its stance on quality, distinguishing it through simplicity and sophistication from the run-of-the-mill cinema.

Kinocenter Ideal & Schloss
Kasinostr. 18, 5000 Aarau
T 062 822 0582 F 822 20 71

Solution

The logo designed by Wild & Frey is, in itself, deceptively simple in appearance and can be reproduced easily and cheaply on tickets or posters. Being black and white it can even be photocopied without losing impact. In the logo, the letters of the name Kinos Aarou – of which, luckily, there are an equal number in each word – form the spool holes at the side of a reel of film, suggesting at a glance the nature of the business.

For the letterhead, the designers sourced oversized sheets of paper which were cut down by the printer, Digital Print, to leave a tab protruding from the top centre of what was now an A4 sheet. By sourcing the oversized sheets rather than just cutting the shape from a sheet of A3 paper, the designers reduced paper wastage and minimised costs. The logo was applied by printing the tab black and removing the letters of the cinema's name from its sides with very precise die-cuts.

The cuts are not straightforward and the scale on which the letters were reproduced was so small that the design took the printers to the limits of what is technically possible. To increase the chances of success, Wild & Frey gave the job to a specialist printer. When a letter is sent, the tab is folded over the sheet, casting a shadow where the light hits it.

Client
Casson Mann

Design company
Bell

Brief
Roger Mann and Dinah Casson are the two
partners in the interior design firm Casson
Mann. The pair have been in partnership for
ten years, using stationery designed by Mann,
but when the company recently started to win
big commissions from clients such as London's
Victoria & Albert Museum and Science
Museum, they decided to have the stationery
redesigned to reflect their changing status.
The pair were also keen to maintain a friendly,
if professional appearance, and Mann specified
that the letterhead should be able to work in
both portrait and landscape formats to enable
him to sketch on it.

Casson Mann Designers
4 Northington Street London WC1N 2JG

DINAHCASSONNAM

T 0171 242 1112 F 0171 242 1113

Solution

Bell's solution is a letterhead that works both upside down, right way up and sideways. The names Casson and Mann share the letter 'N' at their ends, which was emboldened by designer Nick Bell to suggest collaboration and the complementary nature of the working partnership. As the type is arranged vertically rather than horizontally, the letterhead can be used either right way up, with the address in the bottom left-hand corner, or upside down, with the address in the top right-hand corner.

The fact that it is ranged up the sides of the sheet, with a continuous line of text saying 'Casson Mann' also running up the right-hand side of the sheet, allows the letterhead to be used in a landscape format without looking unnatural. That continuous line of text also acts as a column divider, allowing the letterhead to be used as an invoice. On the business cards, the names of Casson and Mann also share a letter, and the pair's Christian names are picked out in a lighter shade of grey to suggest friendliness and the personal touch.

Casson Mann Designers
4 Northington Street London WC1N 2JG

ROGER**MANN**OSSAƆ

T 0171 242 1112 F 0171 242 1113

CASSONNNAM

Casson Mann Designers
4 Northington Street London WC1N 2JG
T 0171 242 1112
F 0171 242 1113

Dinah Casson Roger Mann

Casson **Mann** Limited Company Registration no 3261096 England & Wales
Registered Office 1 Penning House Tent London E2 7PR VAT no. 446 0115 12

MANNOSSAƆ

Client
Nick Turner

Design company
Alan Dye

Brief
Nick Turner is the in-house photographer at the
London-based design consultancy Pentagram.
When he wanted a stationery system, he asked
Pentagram designer Alan Dye, who has since
left the company, to work on the project.
Simplicity was the order of the day, with Turner
requiring only a business card and letterhead
which he wanted to look restrained and
graphically simple.

Nick Turner Photographer
13 Tanners Hill
Deptford London SE8 4PJ
T 0181 691 9044
M 0973 339659

Solution
Alan Dye followed Turner's instructions almost to the letter, using no illustration and setting the type, printed in red and black inks, in American Typewriter. However, he couldn't resist making a reference to the nature of Turner's business using a subtle die-cut at the edge of both letterhead and business card. The unusual shape is taken from the crop on the edge of a 5 x 4 transparency, a shape familiar to anyone who deals with photography and photographers on a regular basis.

The shape was reproduced at actual size so Dye was able to supply the printer, Loughlin Print, with an actual transparency as artwork. The off-white paper stock was selected for its classic look and feel, but Dye had to make sure that it was heavy enough to support a die-cut without losing its edge.

Client
Sutherland Building Services

Design company
HGV

HGV partner Jim Sutherland's brother runs a
small building company and asked HGV to
design him a letterhead and business card.
His requirements were that while the job
should not be too expensive, it should allow
him to stand out from the competition.

188 189

62b Saltoun Road
London SW2 1ER
Telephone 071 738 6751
Mobile 0831 817 208

Solution
Literal stand-out was the chosen route as Jim Sutherland wanted to include an element of three-dimensionality in the letterhead and business card as a reference to the building trade. This was achieved through the use of two simple die-cuts on the first fold line of the letterhead which, when the scored and folded letter is opened, produce a red house brick on the right-hand side of the sheet.

Because the technical requirements of the job were not great – the colours and die-cuts were comparatively simple – the printing could be done by a basic printer, making the letterhead affordable to a small company.

Client
Celcius Films

Design company
Segura Inc.

Brief
New York-based film production company
Celcius films commissioned Segura Inc.
to design a stationery system that was both
graphically impactful and at the same time
modern and clean.

Solution
In reconciling the two demands, Segura Inc. 'broke the rules' of letterhead design. Having decided to consider the sheet as a whole as a canvas, the designer Carlos Segura chose to put the address and other typographic elements on the reverse. The nature of the company's business was referenced through illustrations of glowing circles of light, suggesting the lights of film studios.

Further reference to the industry was made through the use of die-cuts at each corner of the letterhead as Segura felt that the rounded edges would be reminiscent of an aesthetic associated with Hollywood glamour of the 1940s and '50s.

CELSIUS FILMS INCORPORATED.

37 east 18th street
new york, new york. 10003 usa

212.253.7400 (t) 212.253.8199 (f)

Client
Upside Down

Design company
Intro

Brief
Seeing things from a different perspective is
the unique selling point of Edmundo, a film-
maker whose work is mainly in the area of TV
commercials. As a Spaniard working in
London, and a leading creative independent in
his own right, Edmundo wanted his stationery
to reflect the fact that his company, Upside
Down, stands apart from the herd, striving to
be different and original. Due to the nature of
the industry in which he and the advertising
agencies who form the bulk of his clients work,
the letterhead also had to be fun, eye-catching,
and creatively inspired.

Solution
Rendering the company's name graphically,
Intro printed the name and contact details
literally upside down, at the bottom of the sheet,
so that they can be read only when the sheet
is turned so that the typewritten letter itself is
now upside down. A hint of Edmundo's own
personality comes across in a collection of
four photographs of the film-maker himself, also
printed upside down, demonstrating how to
view the letterhead from 'a different perspective'.

59

Client
Glasgow 1999

Design company
MetaDesign London

Brief
Glasgow was selected as the UK City
of Architecture and Design 1999, and as such
it organised a programme of events and
initiatives, housed in a specially converted
building, to promote those disciplines. Its
organisers decided that a specially designed
typeface was needed to use as an identity for
the events, and an international competition
was arranged.

194 195

Deyan Sudjic
Director

Glasgow 1999
UK City of Architecture and Design

62 Buchanan Street
Glasgow G1 3JE

Telephone +44 (0)141 248 6994
Facsimile +44 (0)141 248 8754

arts²⁰⁰⁰
an Arts Council initiative

This was won by MetaDesign London, which was then asked to create a logo as well as a complete typeface. Before these were complete, however, Glasgow 1999's organisers realised that they needed a range of stationery for promotional purposes.

Solution
In the absence of a completed logo or typeface, MetaDesign had to find an alternative way of identifying the programme and representing the city. A city map was abstracted by dividing and colouring it along the lines of its postal districts and applied to the reverse of a sheet of A2 paper.

From this, two letterheads, one continuation sheet, and three compliments slips are cut, each carrying on its back a further abstracted fragment of the city map, which became a sort of interim identity.

Client
Silk Purse

Design company
The Partners

Brief
When the architectural practice Plinke Leaman
& Browning discovered that no software
program existed that fitted the particular
requirements of architects in monitoring costs
and planning the use of resources, it designed
its own, named it Prophet, tested it and then
set about marketing it to other architects.
Reckoning that computer software was a rather
dry and boring product, PLB wanted to inject
an elements of wit into the identity of the new
business, which after an internal competition,
was named The Silk Purse Company.

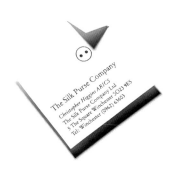

The Silk Purse Company
Christopher Higgins ARICS
The Silk Purse Company Ltd
5 The Square Winchester SO23 9ES
Tel: Winchester (0962) 63603

The Silk Purse Company L
5 The Square Winchester SO2:
Tel: Winchester (0962) 63603
Registered in England No 2019666
VAT Registration No 411 9532 71
Directors
Nigel Charlesworth DipArch
Stephen Alsford BSc MTech
Christopher Higgins ARICS
Clive Houghton MCIOB

Solution
The name Silk Purse refers to the old expression 'making a silk purse out of a sow's ear' – taking something ordinary and turning it into something extraordinary. Design company The Partners took this as its cue for the identity, and referenced the expression through the use of a fold in the top right-hand corners of the letterhead, compliments slip and business card.

Only the area designed to be folded is printed in pink on the reverse of the sheet, which, when a simple snout-like graphic is added, makes the overall effect decidedly piggy. Through adopting a minimalist approach, the designers hoped to ensure that their clients would not be mistaken for butchers, and that recipients would be sufficiently charmed by the wit in the design to remember the company name while overlooking the more tedious aspects of the product.

The Silk Purse Company

Client
Tim Flach

Design company
Roundel

Brief
Tim Flach is a London-based photographer
best known for his work with subjects from the
natural world. When he commissioned Roundel
to design his stationery, he was keen that the
letterhead, compliments slip and business card
should reflect not only the subjects with which
he works, but also communicate that he uses
a variety of unusual photographic techniques.
It was also important that the stationery would
act as much as a promotional device as a
communications tool.

Tim Flach Photography

Tim Flach 17 Willow Street London EC2A 4QH T: 0171 613 1894 F: 0171 613 5602 Mobile: 0836 372 641

Date

Solution

Roundel illustrated the stationery with a series of Flach's blue-tinted 'photograms' of the natural world, fulfiling the brief's requirements that the stationery should reference his technique-based work and his subject matter. The letterhead and compliments slip were made unique and particularly distinctive, however, by the decision to produce them in the same sizes as photographic paper: the letterhead, for example, is ten by eight inches, a standard photographic measurement, and works in a landscape format. This clever touch not only references Flach's business – photography – but also makes the letterhead memorable and distinctive.

Tim Flach 17 Willow Street London EC2A 4QH **T:** 0171 613 1894 **F:** 0171 613 5802 **Mobile:** 0836 372 641

Tim Flach Photography

Tim Flach 17 Willow Street London EC2A 4QH **T:** 0171 613 1894 **F:** 0171 613 5802 **Mobile:** 0836 372 641

Date

with compliments

Client
Celia Keyworth

Design company
Pentagram

Brief
Celia Keyworth runs a catering company that prides itself on the quality of its food and the friendliness of its staff. The waiters and waitresses, who are mostly out-of-work actors and actresses, give the company a slightly Bohemian air, unlike some of Keyworth's more formal competitors, and she was keen to have these qualities reflected in her stationery.

200 201

Solution
To suggest the deliciousness of the food
and inject a note of levity into the material,
Pentagram partner John Rushworth created a
bite-mark logo that was applied to letterheads,
business cards, brochures, moving cards,
folders and any other Celia Keyworth
communication through the use of a die-cut.
The stationery has been redesigned since
the mark was first introduced, but the die-cut
in the top corner has remained.

Celia Keyworth

Celia Keyworth's Food
108 Torriano Avenue
London NW5 2SD
Telephone 071 267 8872
Fax 071 482 1426

Client
Intro

Design company
Intro

Brief
Design company Intro felt that the way it was perceived within the industry and by potential clients did not fully do justice to its abilities. The company was well known for its work in the music and youth-oriented sectors, but felt that potential clients in the corporate sector might be put off by this image. However, while Intro wished to convince a new breed of client that it was available for corporate work, it had to avoid alienating its existing clients or diminishing the strong reputation it had built in that area.

35 Little Russell Street
London WC1A 2HH

+44 (0)171 637 1231

+44 (0)171 6

Telephone

Intro

Intro	35 Little Russell Street London WC1A 2HH	+44 (0)171 637 1231
		Telephone

0973 221688	+44 (0)171 636 5015	+44 (0)171 631 3269
Mobile	Facsimile	ISDN

as@intro.demon.co.uk		Adrian Shaughnessy
Email		Creative Director

Solution

Intro's solution was to create several different letterheads around a flexible logo that was designed and introduced at the same time as the stationery redesign. The mark – three coloured dots – was essentially corporate in appearance, but could be applied to the stationery in a number of ways. Printed straight onto the sheet, the three dots and the clean, Swiss-influenced typography that is another of the company's hallmarks add up to a letterhead that might be sent to a bank or corporate client.

The letterhead shown here, however, retains some of the playfulness and fresh, quirky originality for which the company is known. The letterhead uses three die-cuts which, when the sheet is folded, expose the three colours of the logo from three images printed on the reverse of the sheet. In this way the corporate look is subverted in a way calculated to appeal to Intro's clients in the creative and youth-oriented industries.

Client
Sandringham School Stamp Club

Design company
Billy Mawhinney

Brief
Sandringham School in St. Albans, England, is a government-funded school taking pupils from the age of eleven until eighteen. The commitment of its teachers has made it a great success story, to the extent that its head teacher has been appointed to a government advisory body. Parents are actively encouraged to help the school in any way that they can, and those working in fields such as advertising and design are occasionally asked to provide design and promotional work for the school.

The Sandringham School Stamp Club wanted a printed letterhead of its own for communication with members, but could not afford the paper and print costs. A solution was found by parent Billy Mawhinney, who was at the time creative director of advertising agency J. Walter Thompson.

Solution
Mawhinney recognised that, as the Club could afford neither expensive paper stock nor printing, a letterhead was needed which used neither. The paper is recycled A4 manila envelopes, while the postmark logo at the top of the sheet is applied with a rubber stamp, made to order by Mawhinney, of a type which can be bought cheaply at stationery stores. The effect is completed by the addition of a one penny stamp. The result is an appropriate, impactful letterhead that comes within the budget even of a school stamp club.

206–231
Materials

ARTOMATIC

65 Stirling Road
London W3 8DJ
T 0181 896 6666
F 0181 896 6611
ON 0181 896 6822
artomatic.co.uk

ANNI KUAN

Client
Rollmann

Design company
Birgit Eggers

Brief
Lies Rollmann is a freelance architect working in the Netherlands. Her style is simple, which belies the fact that she is interested in using unusual materials in her work. As a sole practitioner, working for a wide variety of clients, her stationery system had to reflect those characteristics, as well as being flexible and relatively inexpensive. It also had to reflect the qualities of her own work - 'designed' without being fussy, practical and yet stylish.

Solution
Designer Birgit Eggers chose to base the system on simple, informative adhesive stickers. The advantages of this are twofold. First, the stickers can be used for business cards, letterheads, architectural plans, sketchbooks and so on, saving the expense of printing all of those items individually. Second, the stickers can themselves be attached to materials that would otherwise prove difficult to print on.

The diversity of materials used in Rollmann's architectural work can therefore be reflected in those used in her communications. Eggers sourced and supplied materials as diverse as lightweight, translucent sheets of tracing paper and a black compliments card covered in a fine web of cotton thread. Because of the flexibility of the sticker system, Rollmann can add to the range of materials in the future if she chooses, or even create bespoke cards or letters for particular jobs.

Client
Kid Marketing Group

Design company
Segura Inc.

Brief
As consumers become ever more fragmented in their consumption habits, and ever more advertising aware, agencies find ever more sophisticated ways of targeting them. The Kid Marketing Group, based in Chicago, is a division of the advertising agency DDB Needham Worldwide, set up specifically to market products to children. Although the letters and business cards would have an adult audience, when the agency commissioned Segura Inc. to design its stationery, it requested that the stationery should look like it was intended for children, with a playful, colourful tone.

Kid Marketing Group

DDB Needham Worldwide

303 East Wacker Drive, Chicago, Illinois 60601-5282 tel 312-861-0200 fax 312-552-2383

Solution

Segura Inc. devised a logo for the Group that appears to be hand-drawn with a crayon, and added other touches to the stationery reminiscent of the paraphernalia of childhood: the reverse of the sheet is covered by a typographic illustration saying things like 'cereal' and 'toys', for example, and there are spaces on the back of a business card in which its owner can fill their own name, address, job title and so on, in the manner of children's school books.

The effect was completed by the choice of paper stock – a recycled, uncoated stock containing coloured speckles within the sheet. The colours flecking the paper echo those in the logo and contribute to the overall sense of childish colourfulness and gaiety.

DDB Needham Worldwide

Kid Marketing Group

303 East Wacker Drive, Chicago, Illinois 60601-9282
tel 312-861-0200 fax 312-552-2383

Client
Artomatic

Design company
Artomatic

Brief
Artomatic is a creatively driven printing
company, but when it comes to producing its
own stationery, the printers are not so much
concerned with showing what they can do, as
doing what they like. The company's identity
was originally designed by the influential
graphic designer Malcolm Garrett, and he
continues to work with the company on an
informal basis whenever updates are required,
but the choice of materials is left in the hands
of those whose business it is to know what
they are capable of – the printers themselves.

ARTOMATIC

65 Stirling Road
London W3 8DJ
T 0181 896 6666
F 0181 896 6611
ISDN 0181 896 6622
email artomatic.co.uk

LHOOQ LIMITED T/A ARTO
REGISTERED OFFICE

Solution
As Artomatic began as a screen-printing company, its letterheads were traditionally screen-printed. However, when the company grew to a point where screen-printing was no longer feasible, the printers aimed to achieve a similar effect by using a holographic foil over which the company logo was litho printed. As holographic foils are susceptible to damage in the heat of desktop laser printers, the decision to use a foil necessitated testing many different papers to find one with sufficient substance and tooth to hold the foil and withstand the rigours of laser printing.

Most of the firm's business cards are made from stiff brown card, but a chance connection with a client opened up a source of one material with irresistible qualities, leading to a second run of cards: at one point in its growth, Artomatic took over a smaller firm of printers, G & B Arts, one of whose clients was Formula One motor racing team McLaren, through whom Artomatic was able to source the carbon fibre – the substance from which racing cars are built – for its business cards.

Carbon fibre is the most shatterproof material in the world, making it difficult for recipients of the card to simply scrumple it up and bin it. An added advantage is that the cards, like the letterhead, enhance Artomatic's reputation for creatively led printing on strange materials using unusual processes.

Client
On Stage

Design company
Area

Brief
While it does not design clothes itself, German
fashion boutique On Stage sells clothes by
top designers from all over the world. When
it commissioned London-based graphic
design company Area to create its stationery,
the brief asked for a sense of sharpness
and sophistication.

Solution

The project began with the creation of a logo. The 'O' of On Stage was turned into a globe, suggesting the company's global supply network. Locations on the world map were picked out in foil blocks, as was the name itself, to lend an air of modern sophistication to the design. In accordance with German legal requirements, information such as the company's banking details are included on the letterhead, alongside its address, arranged down the right-hand side of the sheet. Area used both serif (Didot) and sans serif (Futura) typefaces to suggest modernity with respectability.

The director of On Stage had asked that he be given his own letterhead in order to distinguish his communications from those of others in the company. This was achieved through printing the director's letterhead on tracing paper while the standard letterhead is on a plain white uncoated stock, thus introducing a hierarchy of importance through the use of materials.

Franco Bruccoleri

Fashion Stage
Franco Bruccoleri GmbH
Zeppelinstraße 47
81669 München
Telefon
+49 (0)89 48 06 01/0
Telefax
+49 (0)89 48 06 01 40

Showroom
Lindemannstraße 37
40237 Düsseldorf
Telefon
+49 (0)211 68 11 90
Telefax
+49 (0)211 679 82 12

Client
Esprit Europe

Design company
HGV

Brief
Esprit Europe is a parcel delivery service and
a subsidiary of Eurostar, the company that
operates trains running through the Channel
Tunnel between England and France. The
company was being launched into a crowded
marketplace populated by household names –
its competitors are well-established
international express delivery firms such as
FedEx, DHL and TNT, each of which has been
operating in the market with great success for
many years. Esprit Europe realised from the
outset that it could not afford to match the
advertising spend of those companies and
therefore decided not to try. Instead, it opted
to concentrate its marketing spend on the
creation of a strong graphic identity, including
a stationery system.

Solution
As well as a logo suggesting a speeding parcel in the shape of a Eurostar train, HGV gave the company an aesthetic based on the graphic ephemera of the couriering business – delivery vans, for example, look like a parcel with a brown livery, and an address label and 'Urgent' sticker on the side. The letterhead itself uses a brown packaging paper called Paperback Craft to reinforce in the mind of the recipient what sector the company operates in.

The use of brown paper and card, not only on the stationery range but also in brochures, direct mail and so on, has given the company as strong and recognisable an identity as it could have hoped to achieve through a vastly more expensive television advertising campaign – the marketing route preferred by many of its competitors.

Client
Anni Kuan

Design company
Sagmeister Inc.

Brief
Two worlds collide in the collection of fashion
designer Anni Kuan. Her clothes are essentially
Western but with a strong Eastern influence.
They are simple in style with playful touches.
It was the nature of the collection itself that
provided the brief when Kuan commissioned
Sagmeister Inc. to design her stationery.

218 219

Solution

Designer Stefan Sagmeister looked for a way to express the Eastern influence on Kuan's clothes without resorting to clichés such as the use of Chinese characters. Instead, the meeting of two cultures is represented typographically through splitting the letters of the name Anni Kuan into their vertical and horizontal components. On the business card, for example, the name is revealed when the card is folded and die-cuts between the vertical lines on its front face expose the horizontals and diagonals printed on the inside of the card, spelling the name.

A similar effect is created by the letterhead when it is folded and placed inside an envelope. Sagmeister created a bespoke translucent vellum envelope, onto which were printed the vertical components of the logo. When the letter is folded – it is a relatively complicated and unusual fold – and placed inside, the horizontal components line up with the verticals to complete the name. Besides allowing Sagmeister to 'build' the logo in two stages, the choice of materials for the envelope also hints at the look of Kuan's own designs – many of her dresses comprise a sheer wrap over an opaque base layer.

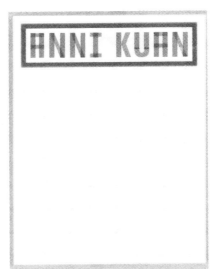

ANNI KUAN

242 W 38TH ST NEW YORK NY 10018 PHONE 212 704 4038 FAX 704 0651

Client
Glasshammer

Design company
HDR Design

Brief
Having created the ironic name 'Glasshammer'
in conjunction with HDR Design, this model-
making company asked its designers to create
a logo and stationery system. Glasshammer's
clients are advertising agencies and the
stationery had to appeal to them, but not in
a way that was artificial. The company also
requested that the stationery should have an
element of 'special effects' about it, but that
it should still look sober and professional,
reflecting not only the seriousness with which
the model makers approach their work, but
also the precision involved in their craft.

Vat Reg Number
626 1915 42

Solution
A balance was struck by combining typographic clarity with an unusual paper stock. The translucency of the Simulator paper references the 'glass' in the company's name, and also allows its new logo, a hammer overlaid on a letter 'G', to stand out. The compliments slips were made out of the same paper, while the business cards are made out of tracing paper. An element of designer/client interactivity was introduced into the design process as Glasshammer's employees were invited to choose a crop of the hammer and 'G' logo to illustrate their own business card.

Partners
Justin Buckingham
Katharine Scott

Glass**hammer**

Studio
71 Lambeth Walk
London
SE11 6DX

Phone/Fax
071 582 5802

Client
Rachel Eager

Design company
Werner Design Works

Brief
As a young copywriter, fresh out of college,
Rachel Eager needed stationery more to attract
and develop new relationships with potential
clients than to communicate with existing ones.
She decided that she would like to target
design companies and advertising agencies
looking for someone with a sense of fun rather
than a more corporate approach, and briefed
Werner Design Works to create a stationery
system that would reflect this.

222 223

After a consultation with the designers, it was also decided that Eager, who had only recently graduated from college, should adopt an honest approach in her pitches, and not pretend through her stationery to be more established and experienced than she was. Budgetary constraints also meant that while she wanted a distinctive, entertaining stationery system, it had to be inexpensive.

Solution
Developing a school theme, and hinting playfully at the fact that Eager was a recent graduate, lined paper was sourced at low cost from a school supplies shop. To save the cost of printing the sheets, a range of stickers carrying Eager's contact details was created. These could be affixed not only to the letterhead itself but also to other communications such as parcels or invoices.

A set of folders or pockets, sourced at auction from a bankrupt printer, was also added to the stationery system. In the US these have a particular resonance as examination papers and school reports are usually submitted in this way. The business cards were printed on Beveridge Placard Board which, because Eager only required a small number of cards, the designers were able to get for free as samples.

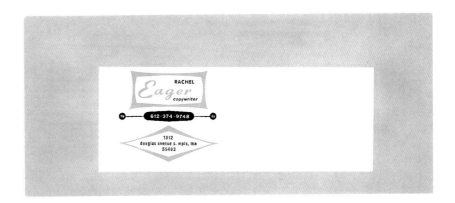

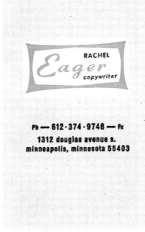

Client
Ursula Wild

Design company
Wild & Frey

Brief
As the sister of Heinz Wild, a partner in design company Wild & Frey, Ursula Wild did not have to look far when she wanted someone to design a range of stationery for her business. Ursula Wild is a specialist in foot massage and related relaxation techniques based in Zürich, Switzerland. The service is very personal and the individual client is important and well taken care of. It was important that the stationery should communicate this with a feel that captured both the personal and the medical professional aspects of the business.

The specific stationery items she requested were a letterhead, business card, envelope and appointments card, but it was stressed that the system should be flexible enough to allow for future additions – she has recently started selling her own treatments in bottles, for example.

Solution
The designers built flexibility into the stationery by using stickers. These had to precisely match the colour of the letterhead and business card, to which they would be attached, and so Wild & Frey sourced an appropriate stock for both the stickers and the stationery items themselves from German paper maker Gmünd, and asked the printers, Digital Print, to give the stickers an adhesive backing. The paper, which is slightly rough with a hand-finished feel, suggested the purity and precision of a medical process through its clean, white appearance, but this was complemented by its warmer, more natural texture, which gives it the personal feel demanded by the brief.

Another 'personal' touch is found on the business card, which, when given to important customers can be tied with string. The time involved in preparing the card suggests that it is precious, and that its recipient is important to Ursula Wild, promoting good client relations.

URSULA WILD

Diplomierte
Fussreflexzonen-Masseurin
Schossbaldenstrasse 38
3006 Bern
Telefon 031 351 12 54

Client
Photonica

Design company
Frost Design

Brief
When the big Japanese photolibrary Photonica
opened a headquarters for its European
operations in London, it commissioned Frost
Design to create a range of stationery
materials as part of a new identity which was
to play a significant part in announcing the
library's presence as an autonomously
operating UK office.

Amana Italy S.r.l. Via Via Borgonuovo, 5, 20121 Milano, Italia Telefono 02 86996001 Fax 02 86990979

Photonica

Partita IVA 121 3680157

Solution

Frost Design took the decision not to use any of the photolibrary's images in either the logo, which in the end was a typographic solution, or the stationery, even though the library's images are highly distinctive. Instead, Photonica's Japanese origins were suggested through the use of type and materials: the name Photonica is written vertically down the right-hand side of the page, in the style of Japanese script. Meta was selected as Photonica's corporate typeface. Japanese associations were also made through the choice of paper for the project: a recycled stock – Paperback Metaphor – was picked for the letterhead.

The paper was selected for its rough, grainy texture, which the designers felt was reminiscent of Japanese paper and packaging materials. For each subsequent piece of material designed for the library, Frost Design has sourced an unusual and interesting paper type, and used a range of finishing techniques such as embossing and debossing, to give it the requisite Japanese feel. As a result, the tactility and texture of the materials has, in a sense, become a trademark of Photonica in Europe.

photonica

Amana Italy
Via Borgonuovo, 5. 20121 Milano
Tel. 02 86996001
Fax. 02 86990979

photonica

Brief
Fashion designer Koji Tatsuno is an inveterate
globe trotter. Originally from Japan, he now
works from Paris but it was when he was based
in London with a satellite showroom in Milan
that he asked Area to design his stationery.
Tatsuno's clothes are characterised by unusual
fabrics and a clever use of materials.

KOJI TATSUNO

UKON ITALIA SRL Via Spartaco 10, 20135 Milan, Italy. Tel. 02 5510989. Fax. 02 55180364.

Cod Fisc e P IVA 08883440151, CCIAA 1256069. Trib Milan 274067/7063/17 Cap Soc 20.000.000.

Solution

It was Tatsuno's treatment of materials that gave Area designer Richard Smith his cue in creating the letterhead. Smith selected a lightweight stock – 90 gsm Ingersley Poster Paper – which comes printed red on the face of the sheet. Smith turned the sheet around so that its reverse became its face. Because the stock is very thin, some of the red ink from the side which would normally be printed on (the red side) seeps through to the reverse face – the side on which Tatsuno will write his letters.

Although the side that the letters will be written on is one which wouldn't ordinarily be seen, it has the positive quality of being unique – each sheet is different, and therefore suggestive of quality and expense. The tactility of the stock, which has a rough but fragile feel, also references the fabrics used in Tatsuno's work.

KOJI TATSUNO

UKON ITALIA SRL Via Spartaco 10, 20135 Milan, Italy.
Tel, 02 5510989. Fax, 02 55180364.

Client
Azone & Associates

Design company
Azone & Associates

Brief
The best-known example is origami, but in
general the Japanese are well-known around
the world for their creative use of paper. When
Tokyo-based design group Azone & Associates
redesigned its own stationery, great care was
taken to choose a stock that met all of the
designers' requirements.

Azone+Associates

Design consulting and more.

Solution

Despite being printed in both English and Japanese, the letterhead and business card are very simple in appearance, using a basic serif and only one colour of ink. The letterhead and card were both printed letterpress and it was one of the key requirements of the stock that it should both support the letterpress printing and bring out the colour of the ink. The designers were also determined to use a recycled stock out of consideration for the environment.

Although it is now possible to get recycled grades that are as smooth as any other stock, Azone & Associates wanted the paper to have a rough texture to make the experience of handling the letterhead a sensuous one. The paper selected, Gilesse, was one which met all of the specifications: furthermore, it has a subtle grid of squares running as a watermark through the paper which brings the sheet to life when it is held up to the light, and its off-white colour adds warmth and flavour to an otherwise austere piece of design.

Design consulting and more.

Phone: 03-5411-0336
Fax: 03-5411-0345

株式会社アゾーン アンド アソシエイツ
〒107 東京都港区南青山 3-16-1 メゾン巴 5F
3-16-1 Minami Aoyama 5F
Minato-ku, Tokyo 107 Japan

Haruki Mori ▶ Azone+Associates
Director / Designer

アートディレクター / デザイナー 森 治樹

232–257
Typography

M.

Client
Möhr

Design company
Odermatt & Tissi

Brief
Hans Möhr is, in general terms, a consultant on
cultural matters to government bodies as well
as large firms, but the actual nature of his work
is harder to define. When he commissioned
Odermatt & Tissi to create a stationery system
he explained that while he wanted something
simple in appearance, it should also set him
apart from other consultants working in the
same field.

M** :

Alpenstrasse 31
Postfach
CH-8801 Thalwil
Telefon 01 772 35 35
Fax 01 772 35 36
E-mail
moehr.cmc@bluewin.ch

M**

lic.iur. Hans U Möhr
Kommunikation
Management
Kulturentwicklung

Solution
Because the diverse and imprecise nature of
the services Möhr provides would have been
difficult to illustrate, and because the brief
called for a simple appearance, designer
Rosmarie Tissi opted for a typographic
solution. Setting the 'M' initial and the umlaut
which sits above the letter 'o' in Möhr's name
in Gill, Tissi turned the characters into the
cornerstones of a structure. Three square dots
were also added to the 'mark', against which
the three strands of Möhr's business are
described – communication, management
and cultural consultancy.

The remainder of the text, set in Futura, is
arranged in various positions around this mark
on the envelope, business card, fax header,
invoice and letterhead, but is omitted from the
continuation sheet, which is identified only
by the basic elements of the 'logo'.

Client
Parameta

Design company
Pentagram

Brief
When Jon Greenfield left design company
Pentagram where he had worked as an
associate, to set up his own architectural
practice, he asked his former colleague,
Pentagram partner David Hillman, to design
his stationery. Pentagram, as a consultancy,
is known for its graphic wit and fondness
for word play.

Solution

The name Greenfield had chosen for his practice – Parameta – immediately suggested a typographic solution: the word parameter actually has a precise meaning in mathematics, but it is commonly understood to mean a limit or furthest point.

Hillman opted to break the word parameta into four parts which he ranged around the four corners of the page, creating a visual joke in which the image of the word echoes its sense – Parameta is at the parameters of the page. The company's address, as well as the chunks of the word Parameta, were set in Franklin Gothic.

PARAMETA Architects
Cowcross Court
75-77 Cowcross Street
London EC1M 6BP
Tel +44 (0)171 250 33 32
Fax +44 (0)171 250 37 72
parameta97@aol.com

David Nixon
BA(Hons) RIBA FRSA

PA RA

ME TA

Client
Merens Architects

Design company
Birgit Eggers

Brief
As a freelance interior designer working alone,
Marina Merens needed a stationery system
that was flexible enough to cope with all of her
requirements: it had to be corporate-looking
enough to send to potential clients, while with
sufficient individual personality to emphasise
the personal touch offered to a client by a
freelance designer. In short, Merens was
selling herself, but did not want to look small-
scale and amateurish in comparison with
larger companies.

marina merens · utrechtsedwarsstraat 30b · 1017 WG Amsterdam · tel 020 427 9883 · fax 020 427 3305 · merens@compuserve.com

MERENS
interieurarchitect

MERENS
interieurarchitect

marina merens · utrechtsedwarsstr. 30b · 1017 WG Amsterdam
tel 020 427 9883 · fax 020 427 3305 · merens@compuserve.com

MERENS
interieurarchitect

marina merens · utrechtsedwarsstr. 30b · 1017 WG Amsterdam
tel 020 427 9883 · fax 020 427 3305 · merens@compuserve.com

Solution
Designer Birgit Eggers opted for a typographic
solution, beginning by creating a logo to
represent the nature of Merens' business: the
components of the logo – two 'ones' facing
one another and a colon in between – not only
form an 'M', but also suggest 'one-to-one', a
concept that itself has two meanings in the
case of Merens. As a sole practitioner she
works alone, and therefore enjoys a 'one-
to-one' relationship with her clients, and
furthermore, the ratio is a reference to the
scales used in architects' plans, one-to-one,
of course, being life-size.

Eggers wanted to keep the letterhead
typographically clean to reflects Merens' own
design style, and selected the austere News
Gothic typeface for the address. The choice
of transparent materials relates to the spatial
nature of interior design, with a business
card that can be used to literally encompass
examples of the company's work, thus
becoming itself a three-dimensional object.

Client
MetaDesign

Design company
MetaDesign

Brief
The international design consultancy
MetaDesign was founded by type designer
Erik Spiekermann in Germany. Its letterheads
today are based on original concepts by
Spiekermann and retain evidence of the
company's German roots in their use of
typography. MetaDesign, as a whole, believes
in functionality and simplicity in design
and this is reflected in the letterhead. The
company has offices in Berlin, London and
San Francisco, each of which has a letterhead
based on the guidelines originally set out by
Spiekermann. The example shown here is
from MetaDesign London.

Solution
The letterhead, as a whole, is considered as a piece of information design, and is typographically ordered according to the priority given to each piece of information. Beneath the surface lies an extremely complicated grid that all MetaDesign's communications are laid out on, but the surface effect is of simplicity and clarity.

Dotted arrows show, in a logical sequence, who the letter is from, who it is to, and so on, while the company address is placed in the bottom right-hand corner of the sheet as the information is of secondary importance to the letter itself and the information recorded by the arrows.

The arrows themselves, as well as the typeface in which letters are written, are set in Meta, the typeface designed by Erik Spiekermann. This typeface has the double advantage of being associated with the company, as well as being specifically designed for laser printing, and therefore working effectively on a letterhead. Red bars bleeding off the sides of the page add further functionality to the letterhead, allowing it to be identified within a filing system.

MetaDesign London
5–8 Hardwick Street
London EC1R 4RB
+44 (0)171 520 1000
Fax +44 (0)171 520 1099
mail@metadesign.co.uk

MetaDesign Berlin
Bergmannstraße 102
D-10961 Berlin
+49 30 695 79 200
Fax +49 30 695 79 222

MetaDesign San Francisco
350 Pacific Avenue
San Francisco CA 94111
+1 415 627 0790
Fax +1 415 627 0795

MetaDesign Virtual
www.metadesign.com

You are what you are seen to be

MetaDesign

→ Robin Richmond
Director

Rational Modernism – with character

↓
MetaDesign Berlin
Bergmannstraße 102
D-10961 Berlin
+49 30 695 79 200
Fax +49 30 695 79 222

MetaDesign San Francisco
350 Pacific Avenue
San Francisco CA 94111
+1 415 627 0790
Fax +1 415 627 0795

MetaDesign Virtual
www.metadesign.com

MetaDesign London
5–8 Hardwick Street
London EC1R 4RB
+44 (0)171 520 1000
Fax +44 (0)171 520 1099
robin@metadesign.co.uk

Client
John Rushworth

Design company
Alan Kitching

Brief
John Rushworth, a partner in the international design firm Pentagram, turned to Alan Kitching at the Typography Workshop for a set of multi-purpose stationery for use by himself and his family. Kitching specialises in letterpress typography and, knowing this, Rushworth left the brief open. The only limitations imposed were that the stationery should be suitable for use by the whole family.

Solution

Free from the constraints of corporate design - the personal letters would be mostly hand-written rather than typed, for example - Kitching selected an unusual shape for the letterhead: the squared-off A4 sheet still fits into a standard DL envelope when folded in half, however. The initials of each member of Rushworth's family were positioned in each of the four corners of the letterhead. A continuation sheet was also created for each individual family member, identified through printing the initial in the same place as it sits on the letterhead itself.

In this way, the continuation sheet identifies the sender of the letter as an individual. The continuation sheets used in isolation also double as personal note paper. The type was woodletter from The Typography Workshop's own collection, each item of which is unique, and the stationery was printed letterpress.

Client
Signus Ltd

Design company
HDR Design

Brief
Like many UK companies involved in the high
technology industries, digital data specialist
Signus is based outside London. When it
briefed HDR Design to create a range of
stationery, it requested that the design should
reflect the fact that its work is technical in
nature, but also that the firm is based in
the countryside.

Solution
This marriage of technology and nature was achieved by HDR Design through a combination of typography and illustration. Four separate letterheads were created, one for each season of the year, and each to come into service on a certain, pre-arranged date in the year. Each letterhead is a different colour and carries a different illustration of the company's offices in its bottom left-hand corner.

On the green Spring letterhead, the branches on the trees outside carry blossom; on the yellow Summer letterhead, they have a full covering of leaves; by the brown Autumn letterhead, some of these have fallen to the ground, and by the blue winter letterhead, the branches are bare.

Throughout the year, however, the typography, which is rational and ordered, remains consistent. Vertical and horizontal lines printed onto the sheet divide columns of information, the rigid structure metaphorically representing the way in which digital data is handled by the company.

Signus Limited

Bradbourne House
East Malling
Kent ME19 6DZ
United Kingdom

Telephone
0732 875 000 general
0732 875 111 direct

Telefax
0732 875 333

John Clements
Type Services Manager

Client
Michelle Turriani

Design company
Angus Hyland

Brief
In the tradition of artists the world over,
Michelle Turriani, an Italian-born photographer
based in London, regularly trades his services
as a photographer for payment in kind: when
he wanted a letterhead, he approached
Pentagram partner Angus Hyland, offering to
swap the design work for a portrait photograph.
Other than the fact that Turriani could not
afford to pay a great deal for paper or printing,
Hyland was given a free reign in his design.

HEADED LETTER PAPER
DIN A4 210MM X 297MM
SCHREIBMASCHINENSCHRIFT
PMS RED 032 U
OFFSET LITHOGRAPHY
DESIGNED BY ANGUS HYLAND
PRINTED BY LITHO MAGIC LTD

MICHELLE TURRIANI
13 MORNINGTON AVENUE
LONDON W14 8UJ
UNITED KINGDOM
TELEPHONE NUMBER
+44 (0) 171 6037729

Solution

Hyland recognised that it would be a great help to Turriani if he did not have to pay for printing at all. As a result, and in the general spirit of the enterprise, he approached a printer with the offer to include the printer's name on the letterhead in a swap for its services. This in turn led to Hyland including his own name on the letterhead. From here, it was a short conceptual step – and Hyland felt justified in making conceptual steps in view of the fact that Turriani is an artist – to include the DIN specifications of the paper and the name of the typeface used: Schreibmaschinenschrift. Hyland chose the font for two reasons.

First, it was appropriate: a basic, unpretentious typeface was suited to a simple letterhead. Second, the fact that its name was to be printed on the letterhead gave resonance to the fact that it's called 'typewriter writing' – the font explains itself just as the letterhead explains who it was designed by, who printed it and what size it is. The copy was placed in the top left-hand corner merely because that is where the eye naturally turns first when reading. The overall result is a letterhead that is simple in appearance while subtly conveying a range of information not just about its 'owner' but also about itself.

```
BUSINESS CARD
55MM X 85MM
SCHREIBMASCHINENSCHRIFT
PMS RED 032 U
OFFSET LITHOGRAPHY
DESIGNED BY ANGUS HYLAND
PRINTED BY LITHO MAGIC LTD
MICHELLE TURRIANI
13 MORNINGTON AVENUE
LONDON W14 8UJ
UNITED KINGDOM
TELEPHONE NUMBER
+44 (0) 171 6037729
```

```
COMPLIMENTS SLIP
1/3 A4 210MM X 99MM
SCHREIBMASCHINENSCHRIFT
PMS RED 032 U
OFFSET LITHOGRAPHY
DESIGNED BY ANGUS HYLAND
PRINTED BY LITHO MAGIC LTD
MICHELLE TURRIANI
13 MORNINGTON AVENUE
LONDON W14 8UJ
UNITED KINGDOM
TELEPHONE NUMBER
+44 (0) 171 6037729
```

Client
Typography Workshop

Design company
Alan Kitching

Brief
Alan Kitching at the Typography Workshop
frequently redesigns his own stationery, printing
around 200 copies of each version by hand, on
a letterpress. The letterheads themselves act
as an effective promotional tool, showing the
effects that can be achieved through the use
of letterpress typography, so it is important to
Kitching to demonstrate variety. One of the
advantages of letterpress as a printing method
is that for short print runs it can be less
expensive than using a litho press.
Furthermore, each item printed on a letterpress
is unique, in a way that a computer-designed,
litho-printed sheet can only imitate.

The Typography Workshop
31 Clerkenwell Close London EC1R 0AT
T 0171 490 4586 F 0171 336 7061

Alan Kitching RDI AGI

Solution
In the examples shown here, the name
Typography Workshop is abbreviated to parody
the way Web addresses are written – the irony
being that letterpress, having been in use for
hundreds of years, is rather older than the
World Wide Web. The name 'Typography
Workshop' is written using woodletter blocks,
which, being individual and unique, create
the slightly rough-hewn effect, while the
typographic ornaments scattered around the
sheet demonstrate a little of the variety of type
that the studio owns.

The business cards, set in Wallbaum and
Futura Bold, have a classic, restrained look.
The range contains both landscape and
portrait format letterheads, compliments slips
and business cards,

The Typography Workshop
31 Clerkenwell Close London EC1R 0AT
Telephone 0171 490 4386
Facsimile 0171 336 7061

Alan Kitching RDI AGI

Typ.W/Shop

Alan Kitching RDI AGI
31 Clerkenwell Close London EC1R 0AT
T 0171 490 4386 F 0171 336 7061

Client
Minimum

Design company
Struktur Design

Brief
Minimum, a Danish men's clothing shop, was
aware of the clean, modern and functional
design philosophy of Struktur Design when
it commissioned the company to create an
identity and stationery system. Knowing the
company's work allowed the client to leave the
brief open, safe in the knowledge that its style
and design thinking were appropriate.

Solution
Struktur Design chose to create a typographic play on the company's name: although the name itself was printed large, in an apparent conflict of appearance and sense, the design of the type itself echoes the meaning of the word, as its horizontal length is reduced through the use of specially created and unusual ligatures (the connecting links that join two type characters together). The 'i' is made from the vertical stroke of the 'n', for example.

The 'minimum' mark is printed in the top right-hand corner of the sheet, so that it sits on the line of the first fold and can be read as the letter appears from the envelope. In yet another play on the company name, an abbreviation of the word minimum – 'min' – was applied to business cards, some of which were printed on polypropylene, others on card. The typeface used throughout is the sans serif Akzidenz Grotesk.

Solution
Because Rich's business is words and writing, MetaDesign felt that a purely typographic letterhead would be appropriate. The designers took the initials of the name under which Rich trades – Tim Rich Writer – as the starting point for the identity. The letters 'R' and 'W' were applied to letterheads, while 'T' was applied to continuation sheets. The three letters were all applied at random to both business cards and compliments slips. The letters were printed in black (double hit on the reverse of the sheet to increase show through) on white, as these colours are traditionally associated with writing.

The letterforms are set in Courier, which was also specified as the typeface in which the letters themselves should be written. Although the letters would be written on a computer and laser printed, Courier is a traditional typewriter font, and its use again references the nature of Tim Rich's business while giving a 'classical' impression.

Client
Burrell Architects

Design company
Bell

Brief
Realising that the stationery he was using was
impersonal and anonymous enough to belong
to a firm of accountants or solicitors, architect
James Burrell commissioned Bell to design
a letterhead and business card that reflected
both his professionalism and his creativity.
Burrell was also hoping to make the career
leap from being employed to do detail work on
other designers' buildings, to winning his own
commissions, and hoped that the impression
made by the right stationery design would help
inspire confidence in his abilities.

Solution

Designer Nick Bell's first suggestion was to add the plural 'Architects' to Burrell's trading name. The name was then presented intelligently and attractively in carefully deconstructed Franklin Gothic Bold 2. Bell had selected a translucent paper stock in order that, once it had been printed on both sides, an impression of three-dimensionality would be created, tying in with the nature of Burrell's work.

The show-through effect created by the paper choice also has the effect of creating a highlighted window around the typographic design of Burrell's name, allowing it to dominate the page. On the face of the business card the typographic treatment of Burrell's name is offset to similar effect and impact by the use of a metallic ink.

Client
Johann Kaiser

Design company
HDR Design

Brief
Jewellery making is typically a small-scale activity involving finely honed craft skills and infinite precision. Johann Kaiser, a German jewellery manufacturer, is an exception to the rule. The company mass-produces wedding rings and wanted the scale of its operations to be reflected in the stationery it commissioned HDR Design to create. As a family business, Johann Kaiser has a long history in the manufacture of jewellery, but the latest generation of the family to take over the company is keen to show that it is looking to the future as well as being aware of the past, another quality it wanted to express through its stationery.

Solution
Hans Dieter Reichart, a German based in the UK and the founder of HDR Design, based the letterhead on the DIN system devised in 1920s Germany (although there were certain prescribed elements, such as fold marks, which were omitted from the design). The DIN specifications were adhered to because Reichart felt that the neutrality inherent in norms was more fitting for a big company – and conveying the size of the business was a key aspect of the brief.

Furthermore, the openness of the design reflects an openness in the company. It was also felt that using the DIN system allowed the logo, redesigned and refined at the same time as the stationery was created, to stand out, giving it a greater responsibility in expressing the personality of the company. Reichart also believes that clarity – a function of using the DIN specifications – is itself in a sense 'futuristic', as it allows clear communication in an age of information overload.

This particular letterhead had to contend with more information than usual as it was produced in two languages, English and German, reflecting the fact the Johann Kaiser has an American daughter company. All of the text on the stationery system was set in Univers, a typeface selected for its international, classic modern qualities.

JohannKaiser

Herstellung von Trauringen und
Diamantschmuck aus Gold und Platin
*Manufacturer of rings and jewelry
made of gold and platinum*

Hauptstraße 149
D-63512 Hainburg
Germany
T: +49 (0)61 82 95 09 0
F: +49 (0)61 82 95 09 23
http://www.jk-kaiser.com

JohannKaiser
Herstellung von Trauringen und
Diamantschmuck aus Gold und Platin

Anna Kaiser-Kolb
Geschäftsführer
Managing Director

Hauptstraße 149
D-63512 Hainburg
Germany
T: +49 (0)61 82 95 09 0
F: +49 (0)61 82 95 09 23
http://www.jk-kaiser.com

JohannKaiser GmbH Postfach *POB* 1080 D-63506 Hainburg *Germany*

Ihr Zeichen	Unser Zeichen	Betrifft	Datum
Your reference	*Our reference*	*Regarding*	*Date*

Aufträge (24 Std):
Orders (24 h):
T: +49 (0)61 82 95 09 90

Service:
T: +49 (0)61 82 95 09 81

Buchhaltung:
Accounting:
T: +49 (0)61 82 95 09 82

Sparkasse Langen-Seligenstadt
BLZ: 506 521 24
Ktn-Nr.: 16 004 814
Volksbank Hausen
BLZ: 505 513 15
Kto-Nr.: 3503 011

Dresdner Bank Seligenstadt
BLZ: 505 800 63
Ktn-Nr.: 590 187 400
Postbank Frankfurt
BLZ: 500 100 60
Kto-Nr.: 94 01-601

Johann Kaiser Trauring
und Schmuck GmbH
Sitz und Gerichtsstand Hainburg
Amtsgericht Seligenstadt HRB 1019
Beidseitiger Erfüllungsort ist
Hainburg, USt-IdNr.: DE811215208

Geschäftsführung:
Managing Directors:
Anna Margarete Kaiser-Kolb
Dipl.-Volkswirt Wolfgang Kolb

Clements Ribeiro Limited 48 South Molton

Client
Clements Ribeiro

Design company
Area

Brief
A common response to a naïve style in art and
design is 'a child could have done that'. In the
case of London-based fashion design duo
Clements Ribeiro, the critics would have been
right. The company's logo, which the designers
had originally wanted to look slightly rough
and ready, was designed by a child of their
acquaintance.

After it had been in use for a while, however, the pair realised that the mark was not entirely appropriate or relevant to the direction their work was taking, and that while they wanted to maintain the essential air of naïvety in the type and illustration, they wanted it to be more controlled and slick-looking.

Solution
Area based its new logo on the original – tweaking elements to give it more uniformity and control. The letter heights, which had previously varied wildly, were brought more into line, and the 'drip' effect was re-drawn. The logo as a whole was then applied to the letterhead and the unusually shaped business card using four-colour litho printing.

The whole design, including the finest threads of line in the illustration, was then embossed, making the sheet interesting to both the eye and the touch.

CLEMENTS
RIBEIRO

Clements Ribeiro Limited
48 South Molton Street London w1y 1he
Tel 0171 409 7719 Fax 0171 409 1741

Client
Digital Print

Design company
Wild & Frey

262 263

Brief
Zürich-based specialist printer Digital Print is
a master of its craft, and offers such services
as die-cutting, embossing and varnishing to
a high degree of precision and quality of finish.
When it commissioned Wild & Frey to create
its stationery, it wanted the design not only
to emphasise its quality and status within the
printing industry, but also to show off some
of its skills.

Solution
The project started with the creation of a company logo. Rather than create a rigid, inflexible mark, the designers adopted a shape – a rectangle – that could be applied to all of the communications and be used to demonstrate the various techniques practiced by Digital Print. Wild & Frey applied the mark to a letterhead, business cards, envelopes in a range of sizes, and a 'good for printing sheet' (which is attached to a proof whose quality is sufficient that it is passed for print).

Each item was given a different printing treatment, so that the range as a whole covers silk-screen printing, die-cutting, embossing, varnishes, reverse printing (where the mark is applied to the back of the sheet) and hot-foil stamping (the application of a metallic strip). A match book was also created for promotional purposes, on which the striking surface was in the rectangular shape.

This demonstrated a rare level of dedication on the part of both designer and client as a company capable of making the match book to those specifications could be found no closer to home than Japan. The stationery range as a whole is a good example of how unity can be given to an identity system by something no more sophisticated than a simple shape, which in turn allows the designers the freedom to create something beautiful, functional and memorable.

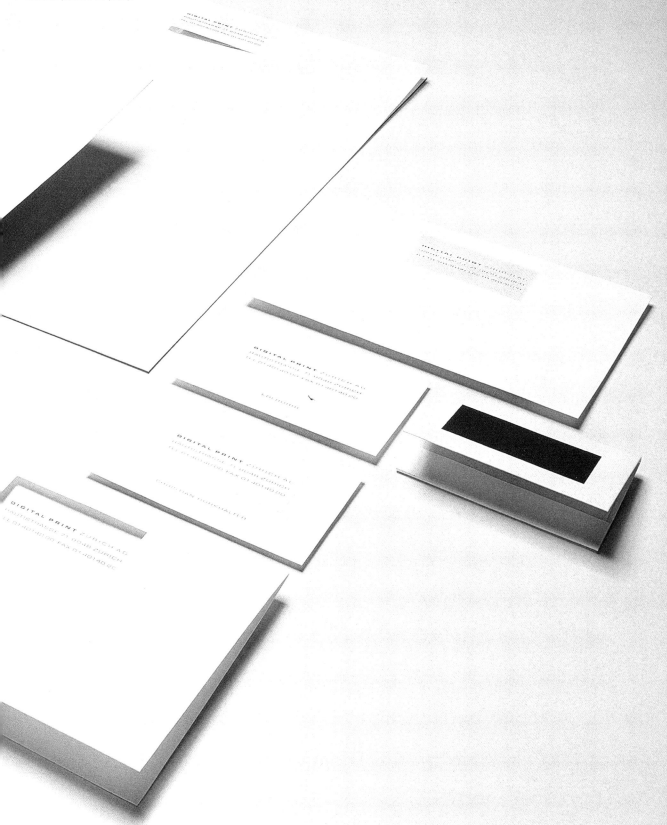

Client
The Savoy

Design company
Pentagram

Brief
The Savoy is one of London's grandest hotels, with an international clientele and a special place in the heart of anyone who has ever eaten in its Grill Room. Design company Pentagram, which has worked extensively with the hotel's owners, Savoy Hotels, was invited to pitch for a redesign of the hotel's identity, including its stationery system.

264 265

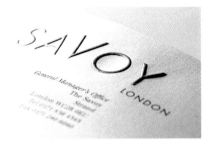

Solution

Taking as its cue the hotel's proximity to 'theatreland' in London's West End, and its tradition of feeding and accommodating the grandees of the stage, Pentagram chose 'theatricality' as a keyword, reflecting both the larger-than-life people who stay there and the look of the hotel, which itself was revamped in the 1930s and is a classic example of art deco design. The hotel's striped awning is a London landmark, and designer John Rushworth was amazed to find that its familiar sans serif lettering, with an enlarged 'V', had never been used on stationery before. He turned the lettering into the hotel's logotype, and applied it to the letterhead through die-stamping.

The mottled, varied tones of the ink applied through die-stamping, and the expense of the process itself, gave the requisite feel of quality that would not have been achieved through simply embossing a litho-printed sheet. The die-stamping process, as well as the asymmetric typography, subtly refer to the 1930s, the decade in which the hotel itself was styled. The business card shown here is in both English and Japanese, and several other bi-lingual variations were produced to cater for the hotel's international clientele.

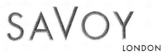

General Manager's Office
The Savoy
Strand
London WC2R 0EU
Tel 0171 856 4343
Fax 0171 240 6040

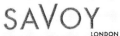

Duncan R. Palmer
General Manager
ジェネラル マネージャー
ダンカン・パーマー

The Savoy
Strand, London
WC2R 0EU
ザ・サヴォイ

The Savoy Hotel Plc.
Registered in England
No. 29022
Registered Office
1 Savoy Hill
London WC2R 0BP

Client
3mv

Design company
Area

Brief
3mv is a company that promotes the music
of its record label clients to shops and radio
stations. Its founder is deeply interested in
numerology, transcendental meditation and
other aspects of what might be termed 'new
age' spirituality. When he commissioned Area
to design 3mv's stationery, he requested that
not only should the stationery make no direct
reference to the business of the company,
but also that it should reflect his interest in
these areas.

3mv Limited. Unit 4E/F West Point
33-34 Warple Way, London W3 0RX
Telephone: 081 740.5959
Fax: 081 740.5943

Phil Clift
Operations Director

Registered Office: as above
Registered no: 2488646

Solution
Area designer Richard Smith began to research numerology and found that the name 3mv could be represented pictorially through the numerological meanings of the numbers and letters in Greek and Hebrew. Thus, from the Greek the '3' became a triangle, and from the Hebrew the 'M' becomes water and the 'V' an eye.

As these were printed on the sheet in a bright orange, the name 3mv, which was blind embossed onto the opposite side of the page, is only seen secondarily, adding an element of surprise and mystery to the proceedings.

3mv Limited, Unit 4E/F West Point
33-34 Warple Way, London W3 0RX
Telephone: 081 740 5959
Fax: 081 740 5943

Client
dias denmark

Design company
Struktur Design

Brief
Struktur Design was commissioned to design
an identity and stationery range for a Danish
women's wear company, dias, whose name is
Greek for 'through'. The stationery had to look
feminine, as its business is women's wear, but
its owners also wanted a look that was clean
and modern – in other words, no flowers or
other supposedly 'feminine' imagery.

dias denmark

Solution

The designers used the Greek meaning of the word dias as a concept, printing the name on the reverse of the sheet so that it shows through. The use of 60 gsm Bible paper as the stock facilitated this, while the use of 'subtle' colours in the reverse printing is in reference to the business of dias.

Metallic inks were used on both the letterhead and the business cards (which were made of tracing paper). Some of the business cards were printed in solid colour, with the name dias reversed out, while others had the name printed onto them, allowing light to shine through.

Client
Blast

Design company
Blast

Brief
When design company Blast came to design
its own stationery, the designers wanted the
letterhead and business card to convey the
personality of the company, which is
professional but fun. Like the personality of
the company itself, the stationery should work
on two levels: on one level the image should
be one of attractive professionalism, but on
another, there should be something to engage
the interest of the readers, and encourage
them to interact with the stationery, and by
extension the design company, on a more
light-hearted and entertaining level.

55 farringdon road
clerkenwell london ec1m 3jb

tel + 0171 242 9565

blas t

55 farringdon road clerkenwell london ec1m 3jb

tel + 0171 242 9565 fax + 0171 242 4668 isdn + 0171 831 6318

Solution
By printing on the reverse side of the sheet, Blast turned what is usually a design problem – show-through – into a feature. While the front of the sheet fulfils the first part of the requirements of the brief – that the letterhead should look professional – when the sheet is lifted to the light the reader is able to see an image which connects with the name of the company. Although the designers opted for conventional litho printing, the use of two special colours – a silver and an orange 'as bright as the printer could mix it' – rather than the usual four-colour process added to the sense of fun and sparkle that the designers wished to create.

As with the letterheads, the designers wanted the business cards to appear at once professional but also fun, with the added benefit that recipients would be more likely to keep them. These were also printed in orange and silver, and as a finishing touch, the name Blast was echoed by the addition of a length of caps of the sort normally used in toy guns, which encourage the recipient to interact with the card by setting fire to it. While the use of special colours and printing on both faces of the letterhead and business cards did add to the drying time, the job did not prove to be significantly more expensive than a conventional letterhead.

fold back stand
place on flat surface
stand well back
light tip of fuse

Client
Radioactive Ink

Design company
Werner Design Works

Brief
As relative newcomers to the business, the
two writers for radio who comprise Radioactive
Ink needed an identity to set them apart from
the competition. As most of their business
comes from advertising agencies, the letterhead
needed to be fresh and fun but, as the duo were
not yet firmly financially established, it had to
be inexpensive.

272 273

Solution
The punning name Radioactive was conceived by the writers themselves, but it gave the designers at Werner Design Works their cue for the letterhead. It was decided to present the writers as a slightly risky alternative to the norm, in a reverse psychology move calculated to get advertising agencies itching to hire them. This presentation was achieved through packaging the letterhead itself as a radioactive document. A silver-backed paper stock suggesting radiation-proof material was sourced, and a blue dot printed on the reverse of the sheet by letterpress.

The effect was completed with adhesive stickers bearing a radioactivity warning on an orange background which were printed at a high-street copy shop extremely cheaply. These can then be attached not only to the letterhead but to any other communications the duo send out.

RADIOACTIVE INK
105 EAST ELMWOOD PLACE
MINNEAPOLIS, MN 55419
FACSIMILE (612) 822-3854

MARK BENNINGHOFEN

Phone (612) 822-3854

Client
Anna Scholtz

Design company
Alan Dye Associates

Brief
It is a commonly heard complaint that high-street retailers don't cater for the larger woman. Filling that niche in the market is Anna Scholtz, a fashion designer who makes sexy clothes for big women. When she commissioned Alan Dye of Alan Dye Associates to design her stationery, the one requirement was that the identity, like her clients, should be big and bold.

Solution
Dye took his client at her word, running the
name Anna Scholtz, set in Franklin Gothic,
across the top of the sheet. Bringing an element
of the sexiness of the clothes into the design,
Dye decided to print the surname using a silver
foil block.

Based on his past experience with foil blocking,
which, like many surface treatments, can
cause lighter papers to crumple and buckle,
Dye requested that the printer, Gavin Martin
Associates, use a stock that was sufficiently
heavy to take the foil block without crumpling.

Unit 9. 81 Southern Row
London W10 5AL
Great Britain
T+44(0)181 964 3040
F+44(0)181 964 5020

annascholz

Client
Opal Sky

Design company
Viva Dolan

Brief
Based in Toronto, Canada, Opal Sky is a
software design firm whose main product
controls bookings and analyses databases for
the travel industry. Viva Dolan had worked for
the company in a previous incarnation and the
strength of the designer/client relationship
allowed Opal Sky to leave the brief open,
although as a new start-up business, it was
agreed that its letterhead should reflect that
although the company is young and at the
cutting edge of the industry, it also has an
understanding of the history of the technology.

OPAL SKY

Solution
The sense of historical perspective was introduced through the flexible mark designed for Opal Sky by Viva Dolan. The spirograph, which is printed on the reverse of the sheet, has associations with the 1960s, although it is not specifically rooted in any one time. This glance back in time was counterbalanced through a combination of paper choice and printing techniques to give the stationery a contemporary feel. A translucent stock was selected, allowing the mark on the reverse of the sheet to show through.

The mark itself is reversed out of solid colour, and a special silver ink was chosen to give the letterhead an appropriately hi-tech feel. The business cards were also printed in silver on Gilclear paper, a heavy card stock that is semi-translucent. Only two colours are used on the face of the sheet, creating an overall impression of clean modernity with a twist.

Client
Cloud Nine

Design company
The Partners

Brief
Introduction agencies often have slightly cheap
and tacky associations in the mind of the
general public, and it was these that the
founder of a new agency wished to dispel
when she briefed design company The
Partners to create a name and visual
manifestation for her business. The image she
wished to project was of a high-class agency
that was serious about its work but at the
same time human and sympathetic. As the
agency's clients would be of both sexes, the
name and identity should appeal equally to
both men and women.

Solution
The name Cloud Nine was suggested by The Partners as it was felt to be suitably restrained yet hinted at the aspirational nature of the agency's potential clients – the name refers to the term for happiness, being on cloud nine, and also has connotations of stature and quality. When it came to creating the stationery itself, the designers wanted to avoid the clichéd route of hearts and flowers, which would have been inappropriate for the image the agency wished to project. Instead, a logo was created by placing figure 9s end on end to create a cloud shape.

The logo was applied to the letterhead through embossing, a technique which, it was felt, had associations of quality and up-scale positioning and also of care and precision – necessary qualities when dealing in affairs of the heart.

Cloud Nine

Liz Poulson BA(Hons) Cert Ed
51 Newnham Road Cambridge CB3 9EY
Telephone 01223 506999 *Fax* 01223 506793
e-mail 101740.3213@CompuServe.com

Client
Helengai Harbottle

Design company
johnson banks

Brief
Helengai Harbottle is a textile designer
specialising in knitwear. She approached
johnson banks to create a logo and stationery
range for her business. The logo, based on
a set of interlocking 'H's, came from the initials
of her name and is reminiscent of the knitting
process in appearance. Both Harbottle and the
designers felt that the logo should be large and
prominent on the letterhead, but the challenge
came in finding a way to do this without
interfering with its functionality.

Helengai Harbottle 2nd Floor 110-112 Curtain Road London EC2 3AH Tel/Fax 0171 729 9546

Solution
In order to show the logo large, without limiting
the amount of space left for typing, the
designers opted to print it on the reverse of the
sheet, creating a show-through effect. The
decision to reverse the letters out of black,
rather than just printing them onto the back of
the sheet, meant that extra care had to be taken
with the choice of printer – johnson banks took
the job to a firm specialised in high-end, quality
work – and also that the paper had to be sealed
before printing began, in order that it did not
soak up too much of the back ink. The fact that
the printing and drying processes would take
longer than usual was also taken into account.

Helengal Harbottle 2nd Floor 110-112 Curtain Road London EC2 3AH Tel/Fax 0171 729 9546

Client
Art Directors' Collective

Design company
Area

Brief
ADC stands for the Art Directors' Collective,
a floating pool of creatives who can be hired
to work on a variety of media projects in areas
such as television programming, advertising
and photography. The group is run by
sponsorship and marketing expert Anthony
Fawcett and ex-Eurythmics guitarist and
photographer Dave Stewart. As the exact nature
of what the group does is imprecise – they will
consider a wide variety of projects – it was
important that the stationery should not define
them too closely. The Art Directors' Collective
also wanted it to have a cool, modern, yet
professional image.

28 2
D Arblay
London
W1V 3FH
Telephone
071 734 0020
Facsimile
071 287 3080

David A Stewart
Anthony Fawcett

Solution
Area created a logo of solid, graphic shapes based on the group's initials, which was applied to the top corner of the sheet. The brief's demand for subtlety and sophistication was met by applying the mark using a spot varnish in a colour only marginally different from that of the paper stock.

Despite the similarity in colour, the logo is easily distinguished because its gloss finish stands out from a matt background. The two similar colours soften the heavy, bold letter shapes, enhancing the image of sleek sophistication the Art Directors' Collective wanted to project.

Menno Witt Schoonmaakbedrijf

Wij ve

Tel 0

Uden A.
Televisior

Unit 3
Chelsea W
Lots Road
London SW

T +44 171
F +44 171

ook tapijtreiniging wassen van ramen reiniging van gevels brand en roetre

2 25 80 Autotel 06 5333 3286 V

Menno Witt Afde

Client
Canna Kendall & Co

Design company
johnson banks

Brief
Canna Kendall is a firm of advertising headhunters based in London. Although the firm itself is just starting out in the advertising recruitment game, and needed its stationery to arrest the attention of its recipients, its founders have been in the industry for a long time and knew how their potential clients thought. When the company commissioned design company johnson banks to create a range of stationery materials, the brief was simple, if demanding: the company asked only that whatever stationery johnson banks designed, it should be good enough to win a prestigious D&AD (design and advertising) Award.

CANNA KENDALL & CO. 83 Charlotte Street London W1P 1LB

Telephone 0171 580 3455 **Facsimile** 0171 580 7974

BEVERLEY PARKER

Solution

As Canna Kendall's business is in matching suitable employees with suitable employers, johnson banks took the theme of complementary partners for the stationery. Across a range of business cards, as well as both A4 and A5 letterheads, the designers created four sets of matched pairs: fish and chips, popeye and olive, dog and bone and egg and bacon. A further element of humour was injected into the images in that some of the supposedly matched pairs only appear to be so: popeye's olive is not his cartoon girlfriend but a small green fruit.

The photographs were taken by advertising photographer Mike Parsons. The images proved to be a success, with clients asking for full sets of the business cards at meetings. The flexible format has also lent itself to other materials such as a Christmas card on which pine needles were twinned with a vacuum cleaner. The stationery did indeed go on to win a Silver Award at D&AD, giving Canna Kendall some much-appreciated publicity in its target market.

CANNA KENDALL & CO, 83 Charlotte Street London W1P 1LB
Telephone 0171 580 3455 Facsimile 0171 580 2974

Client
Glassworks

Design company
Frost Design

Brief
Glassworks is a film-production house, based
at the heart of the UK's TV and commercials
industry in Soho, London. The company is
confident in its size, reputation and creativity
and as a consequence, when it commissioned
Frost Design to create an identity and stationery
system, the brief was left relatively open: all
that was required was that the stationery was
appropriate, given the sector in which the
company does business – its main clients are
the local advertising agencies – and that it
should look good.

Solution
Taking the company's name as the basis for its solution, Frost Design commissioned a model maker to build a letter 'G' in blocks of glass. This was then photographed by Matthew Donaldson, a regular collaborator with the design consultancy, and the image, which has slightly abstract qualities, was applied directly to the reverse of the letterhead.

The soft, green tones of the photograph have a modern, minimal look which would strike a chord with the aesthetically and visually aware denizens of ad-land. The 'G' logo was later applied more widely, including frosting it onto glass doors at the company's offices and creating a pair of table legs in a 'G' shape for its reception desk.

GLASSWORKS LTD

GLASSWORKS LTD

33/34 Great Pulteney St. London W1R 3DE
Telephone 0171 434 1182 Fax 0171 434 1183
ISDN 0171 494 2774

Hector Macleod
Managing Director
Hector @ glassworks.co.uk

Client
Q101

Design company
Segura Inc.

Brief
An alternative music station needs an
alternative stationery system and when
Chicago-based Q101 Radio commissioned
Segura Inc. to create its letterhead, compliments
slip and business card, it asked for something
that was slightly edgy and different.

Client
Q101

Design company
Segura Inc.

Brief
An alternative music station needs an
alternative stationery system and when
Chicago-based Q101 Radio commissioned
Segura Inc. to create its letterhead, compliments
slip and business card, it asked for something
that was slightly edgy and different.

Solution
Segura Inc. realised that although the image
of the radio station suggested a very radical
design, the recipients of the letterhead would
mostly be potential clients such as buyers
of advertising space, and aimed to create a
letterhead that was radical and contemporary
without being off-putting to corporate clients.
The solution was found in illustration.
Screen grabs were taken from music videos,
distressed to the point where they are almost
unrecognisable, and layered to create a visual
impression of the sort of music played on the
station that is at once attractive to listeners,
and acceptable to its clients.

The illustration forms a border to the sheet,
framing the area in which the letter is written
and emphasising it through the contrast
between the dark illustration and the white
paper stock. The words 'Alternative New Music'
are embedded within the border, adding a
typographic element to the illustration. Similar
illustrations were applied to continuation sheets,
compliments slips, folding cards, envelopes,
lined note paper and adhesive labels.

EMMIS Broadcasting Corp. WKQX-FM Merchandise Mart Plaza Ste. 1700 Chicago, IL 60654 Tel: 312.527.8348 Fax: 312.527.5682

Client
Hannah S. Fricke

Design company
Factor Design

Brief
As an advertising copywriter, Hannah Fricke
deals with advertising agencies as an everyday
part of her business. It is to those agencies
that most of her written communications are
sent and it was an important aspect of the
design of her stationery that it should
demonstrate her knowledge of the industry
and of her own craft – writing.

Solution
On the front of the sheet, a numbered scale like the ones found, for example, in word processing packages, runs along the top and down the side of the page, which is intended to imply that Fricke can write copy to fit – an important skill for a copywriter. In order to further demonstrate Fricke's awareness of the needs of an advertising agency, Factor Design commissioned illustrator Tanja Jacobs to create a funny, cartoon-like illustration showing the communication networks that exist within an advertising agency.

This was then printed on the reverse of the sheet. The illustration and the choice of a rich, dark stock also combine to give the stationery a warm, attractive 'personality'.

Client
Harbourside

Design company
Bell

Brief
As part of a plan to develop the disused docks of the city of Bristol in South West England, the Arts Council, a government-funded body, announced a plan to build an arts centre. The building itself was to be designed by Behnisch and Behnisch, an internationally renowned architectural practice, and the task of designing an identity and stationery for the scheme fell to graphic design consultancy Bell. In order to secure funding for the proposed project, it was important to convince the fund-holding bodies, such as the Arts Council and the National Lottery, that the scheme would be as much a resource for the people of South West England as for the artists themselves.

the harbourside centre 2 st. george's court st. george's road bristol bs1 5ug united kingdom
phone +44 (0)117 925 5252 fax +44 (0)117 925 5250
director duncan fraser chairman louis sherwood

Registered Charity no: 1054023 Vat no: 682279013 Registered Company no: 3133490
Registered Office: The Harbourside Centre Limited Narrow Quay House Prince Street Bristol BS1 4AH

SUPPORTED BY
THE NATIONAL LOTTERY
THROUGH
THE ARTS COUNCIL
OF ENGLAND

Solution
With the idea in mind that the identity should suggest a blurring of boundaries between artist and spectator, designer Nick Bell decided against creating a logo of the 'graphic stamp' variety in favour of a mark that represented a coming together of parts. The tonal scale of blues that eventually became the mark is based on an architectural feature of the centre itself, despite the fact that it did not exist when the stationery was designed. One wall of the proposed building was to be made of glass, and overlooked the harbour from which it takes its name.

This would allow light reflected from the water to create patterns on the ceiling inside the building. From the image of a shifting body of water, Bell created the block of blues that acts as the centre's mark. A further reference to the building itself was made through positioning the mark underneath the word 'harbourside'. The ascenders of the letters 'h', 'b' and 'd' and the dot of the letter 'i' are 'mirrored in the mark below, suggesting the reflection of an architectural skyline and the sun in the water of the harbour. Unfortunately, despite the best efforts of both architect and graphic designer, the Arts Council pulled out of the project before completion, pleading poverty.

Sue Sanctuary Marketing Assistant

the harbourside centre
2 st. george's court st. george's road
bristol bs1 5ug united kingdom

phone +44 (0)117 925 5252 fax +44 (0)117 925 5250

with compliments from the harbourside centre 2 st. george's court st. george's road bristol bs1 5ug united kingdom
phone +44 (0)117 925 5252 fax +44 (0)117 925 5250

Brief
Companies involved in the creative industries
often have a problem finding a way to
express that they are both creative and
also professional and organised.

296 297

tilney shane

tilney shane

tilney shane

tilney shane limited architecture and design consultants

5 heathmans road london sw6 4r t 0171 731 8464 f 0171 736 3356 e mail tilneyshane@compuserve com

When Tilney Shane, a firm of architectural and interior designers, commissioned Pyott Design to create a range of stationery, it stressed the importance of communicating that it was both highly creative and imaginative, but also practical in terms of project management and co-ordination.

Solution
A sense of professionalism and pragmatism was lent to the stationery through the use of a rigid grid structure and tidy typography. It was in the illustration, however, that Tilney Shane's creativity was expressed. The twelve images, which were applied to letterheads, compliments slips and business cards, were created from scratch using Adobe's Photoshop software. Although abstract, the images are intended to represent some of the raw materials of the building trade: concrete, glass, wood and cloth.

The twelve basic images were given further colour variations in an effort to increase variety to the point where no one image in itself could be said to represent the company, only a type of image. The system is flexible enough to allow almost infinite numbers of further images to be created and added in accordance with changing trends within architecture and interior design in the future.

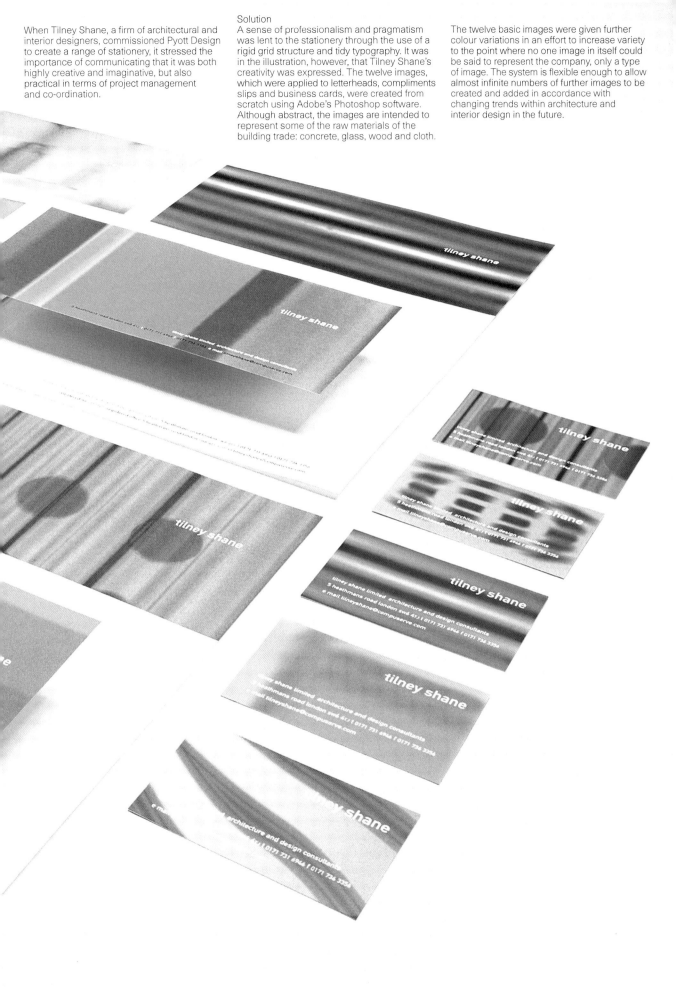

Client
Uden Associates

Design company
Intro

Brief
Uden Associates, a leading independent
television programme production company,
had a stationery system designed in the 1980s
by 8vo which won many plaudits from within
and without the design industry. However, as
TV programming in the UK has changed, with
increasing numbers of programmes made by
small, independent production companies with
a makeshift, do-it-yourself aesthetic, Uden
Associates realised that it was in danger of
being seen as monolithic and wanted to
demonstrate through its stationery that it could
make those kind of programmes as well as the
more serious, high-budget output for which it
was best known.

Solution
While the company was not 'dumbing down' in its programme making, it did want to attract new clients and convince existing ones that it was adaptable and aware of the changing market, and it was with this in mind that Intro set out to create a letterhead that emphasised some of the qualities in those new television programmes – spontaneity, speed, and a rough-hewn aesthetic. A range of six distinct business cards suggested spontaneity and non-conformity, while the letterhead itself, printed two-colour instead of the previous four, made use of illustration to create the appropriate effect. Natural objects were scanned into a desktop scanner and manipulated using an Apple Macintosh.

In order to show clients that Uden Associates had not abandoned the serious programme making on which its reputation is founded, this seemingly random, scratchy, computer-manipulated illustration was counterbalanced by clean, Swiss-influenced typography to retain the corporate, professional air.

Client
Bluewater

Design company
Glazer Design

Brief
Bluewater is Europe's largest retail
development, and is the first of a new breed
of shopping centres that, as a key part of their
offer, will provide leisure activities such as
bars, cinemas and sporting facilities, turning
the shopping trip into a complete day out for
the whole family. Bluewater's developers,
Lend Lease, needed to convey this distinction
to potential buyers of retail space at the site.
At the time the space was put on the market,
however, the building site itself was little more
than an uninspiring mess of puddles, rubble
and cement trucks.

Lend Lease, perhaps mindful of the old saying 'never show a fool a half-built house', realised that if the site itself would not inspire potential buyers, it would need to find another way of communicating its vision, and therefore approached design consultancy Glazer to create a range of materials, including a stationery system, through which it could tell customers about the development.

Solution
It can be difficult for someone looking at a project halfway to completion to appreciate that it will look a lot better when it is finished. Glazer Design realised that images of the site as it was would not sell the Bluewater concept to potential customers, and instead sought a different route. The designers took the name Bluewater as the basis of a virtual sensory experience of the site. Other colour-related, emotionally charged concepts were also created: red roses, green grass, brown coffee beans. Each suggested an aspect of a day out at Bluewater.

These images were then applied to letterheads, postcards and business cards, as well as a brochure and trade-press advertising, ensuring that through all communications with potential customers, a solid brand based on a vision was built. The images proved crucial in conveying to potential customers a sense of what the site they were being asked to buy into might be like at completion.

brown beans by Bluewater

Client
Menno Witt

Design company
Interbrand Newell & Sorrell

Brief
Menno Witt cleans the offices of design
company Interbrand Newell & Sorrell's
Amsterdam branch. Office cleaning, however,
is only one part of Witt's business, which also
includes decorating and construction.

Menno Witt Schoonmaakbedrijf
Tel 030 272 25 80 Autotel 06 5333 3286

Van Musschenbroekstraat 33 3514 XH Utrecht
Rabobank nr. 34.13.05.286 K.v.K. nr. 3012 4135

Menno Witt Afbouwbedrijf
Tel 030 272 25 80 Autotel 06 5333 3286

Van Musschenbroekstraat 33 3514 XH Utrecht
Rabobank nr. 34.13.05.286 K.v.K. nr. 3012 4135

When, in a table-turning exercise, he sought the services of his client Interbrand Newell & Sorrell to create a new identity and stationery range for him, it was critical that the design should reflect all of his areas of endeavour. Although the two businesses are similar, and Witt wanted to promote both at the same time, he was keen that they should remain distinct.

Solution
The solution was a double-sided stationery range using illustration to distinguish between the businesses. On both the letterhead and the business card, a photograph of a paintbrush dripping vivid blue paint represents the building and decorating arm of the Witt empire, and this is contrasted on the other side of the sheet by a leaking sponge to illustrate the office-cleaning business.

Menno Witt is then able to use whichever side of the letterhead caters for the subject of the letter in question – construction or cleaning – while still making the recipient aware that he is available for other types of work.

Wij verzorgen ook

Tel 030 272 25 80 Autotel 06 5333 3286

Menno Witt Afbo

Client
Factor Design

Design company
Factor Design

Brief
Hamburg-based graphic design consultancy
Factor Design saw its own stationery fitting into
a wider scheme of materials produced by the
company, rather like the range of forms in a
bank. To that end, the number 'one' is printed
in the top left-hand corner of the letterhead,
signifying that it is the first in a series of such
forms. This formal concept dictated a formal
design, but the studio also wanted the
letterhead to demonstrate its creativity.

Solution

The solution was found in the use of imagery. The reverse side of the sheet was covered with an illustration reminiscent of the test sheets used by printers to check such things as the spread of ink on the presses. The same sheet is run several times through the press, resulting in a random overlaying of text and images. The process itself was interesting to the designers as it has echoes in some of the design work of the Bauhaus period as well as an aesthetic that developed out of the possibilities introduced by the Macintosh computer.

More significantly, however, the illustration was intended to demonstrate the studio's affinity with the printing process itself, as well as with typography in general. The letterforms used in the illustration were sourced from American printers' catalogues of the 1950s and '60s and, although it is intended to appear random and accidentally beautiful, was actually put together very deliberately.

Brief
Printed Stationery is a firm of printers whose
main target market is the graphic design
industry. The company wanted a letterhead
that would appeal to designers on their own
terms, showing that Printed Stationery thought
the same way and spoke the same language.
It was also important that the letterhead should
show off the company's capabilities as a printer.

306 307

Printed Stationery

326 City Road
London EC1V 2PT
Tel 0171 278 7706
Fax 0171 278 7703

Printed Stationery Limited
Registered office as above
Registered No: 2598525

Solution
HGV used blocks of printers' type, photographed by John Edwards, as illustrations to identify the component parts of the stationery system. By using quotation marks to show the start of text, an ampersand to indicate the continuation sheet and so on, the letterhead demonstrates not only that Printed Stationery understands the sort of graphic wit that appeals to designers, but also makes direct reference to the tools of its trade.

The designers experimented with both tri-tone (containing a special silver ink) and duo-tone reproductions of the images, settling eventually for the duo-tone which, it was felt, brought out the qualities of the metal type more effectively.

Ian Swindale

Printed Stationery

326 City Road
London ECIV 2PT
Tel 0171 278 7706
Fax 0171 278 7203

Ade Borishade

Printed Stationery

326 City Road
London ECIV 2PT
Tel 0171 278 7706
Fax 0171 278 7203

with compliments

Printed Stationery

326 City Road
London ECIV 2PT
Tel 0171 278 7706
Fax 0171 278 7203

Client
Quasi

Design company
Birgit Eggers

Brief
Quasi is a group of three photographers
based in the Netherlands. When the group
commissioned graphic designer Birgit Eggers to
create a range of stationery, the photographers
explained that while the items must identify
them as collectively belonging to the group,
their individual creative personalities were
important and should not be entirely subsumed
by one over-arching identity. As well as
letterheads, Eggers was also commissioned to
design a means by which individual members
of the group could send out examples of their
work to potential clients.

308 309

Solution
Eggers solved the problem of representing three in one by creating one basic letterhead template, from which three separate varieties were made. Each letterhead carries the name Quasi, and also the name of the group member to whom it belongs. Printed upside-down at the foot of the reverse of the sheet are eleven photographs by all three members of the group. Individuality is achieved through the use of a simple die-cut which, when the sheet is folded, highlights one photograph by the group member, which then appears through the hole right way up next to the name of the member to whom the letterhead belongs.

A5 cards bearing examples of each individual photographer's work were also created.
A scored rectangle in the centre of the card means that the business card can be detached, leaving a cropped photograph on the face of the business card. As in the case *of the 'crops' created by the die-cut on the letterhead, this is intended to subliminally reinforce the idea of photography in the mind of the recipient.

quasi[fotografie]

renée frinking

quasi [fotografie]

utrechtsedwarsstraat 30a
1017 WG amsterdam

tel 020 420 49 91
fax 020 420 48 73
mob 06 549 346 64

Terms & Techniques
Like any semi-industrial activity, stationery design and printing has its fair share of arcane terminology. There follows a concise glossary explaining some terms relating to aspects of stationery design.

Paper comes in many more forms than it is possible to list here, so no attempt has been made to do so. Each paper type has its own qualities and characteristics and will respond differently to different print processes. It is advisable to seek a printer's advice when selecting a paper stock.

A series
Refers to the system of DIN or ISO series of paper sizes.

Bible paper
A very thin paper.

Blind embossing
Embossing without using ink to create a raised area in the paper, visible by the shadow cast by the area in relief.

Coated paper
Paper coated in china clay or similar materials to give it a smooth surface.

Continuation sheet
A secondary sheet to the letterhead, usually identified through elements of the design on the letterhead itself, minus the address and other extraneous detail.

Corporate identity
The process whereby unity is given to the visual manifestations of a company's personality through design, identifying its products, property or communications. At its most basic level, this involves the application of the company's logo or trademark.

Custom making
Also known as 'bespoke'; paper made to a customer's own specifications.

Debossing
A depressed design on the paper created by pressing the sheet between two interlocking blocks, one of which has a raised design on it, the other a matching depression.

Die
An engraved metal stamp used by the printer to cut or otherwise alter the flat surface of the paper.

Die-cut
Area cut from a sheet of paper using a die.

Die stamping
Stamping with a die that leaves an 'embossed' design on the surface of the sheet.

DIN
Abbreviation of Deutsche Industrie Norm, a set of industry standards established in Germany in the 1920s and now used across Europe. Subsequently adopted by the International Standards Organization (ISO).

Double hit
Printing a sheet twice to increase the density of the ink.

Embossing
A raised design on the paper created by pressing the sheet between two interlocking blocks, one of which has a raised design on it, the other a matching depression. See also die stamping, thermography and debossing.

Foil blocking
A process in which a thin layer of metal foil is applied to the surface of a sheet of paper using heat.

Font
Traditional term for a complete set of alphabets relating to one size of typeface, including upper and lower case roman, italics, bolds, figures and punctuation marks.

Four-colour printing
The process of producing printed colour using four separate plates to print yellow, magenta, cyan and black to give an impression of full colour. 'Special' colours such as silvers can be added on successive plates.

gsm
see weight.

House style
A set of guidelines ensuring consistency throughout all of a company's communications.

Ink-jet printer
Computer-linked printing device in which the image is created by high-speed jets of ink.

ISO sizes
see DIN.

Justified
Typographic arrangement in which the letters and words of each line are spaced to fill a particular column width. See ranged left/right.

Laser printer
A common computer-linked desk-top printer in which beams of laser light activate a photoconductive powder, creating an electrostatic image which is transferred to the paper through heat.

Letterhead
The printed design on letter stationery.

Letterpress
A traditional form of relief printing in which ink is applied to the paper through pressure. Raised blocks of type and image are pressed onto the sheet, leaving an impression where they come into contact. Usually used for shorter print runs or very high end jobs.

Litho printing
The most common letterhead printing process based on the principle that oil and water do not mix. The design, which is treated to be water-resistant but attractive to oil and grease, is transferred to the page from flat plate by means of a rolling cylinder. Also known as offset litho, lithography and photolithography.

Logotype
Letters or words in a distinctive form, often used as, or as part of a company's logo.

Ranged left/right
Typographic arrangement in which lines of unequal length are aligned along the left- or right-hand margin, with a ragged effect on the opposite margin.

Reverse printing
Printing on the reverse face of the letterhead sheet, often with the intention of creating a show-through effect.

Roman typeface
Typeface whose main strokes are capped by a terminal stroke.

Sans serif typeface
Typeface whose letters lack a terminal stroke at the top and bottom of the main strokes of a Roman typeface.

Screen printing
A process evolved from the traditional silk-screen method. The ink is applied to the sheet through a fine screen made of fabric or metal. The process has the advantage of being able to print on materials other than paper such as plastic and metal.

Thermography
A raised, glossy surface is created by sprinkling resin onto wet ink.

Trademark
A logotype or symbol used to identify the products, property or communications of a particular company.

Tooth
The rough texture of the paper surface.

Typeface
Alphabet created for the purposes of printing.

Typography
The arrangement and specification of type for printing.

Vellum
Paper made from calf skin, or fine parchment papers which imitate this.

Watermark
Design within the paper itself, created by pressing a pattern into the sheet while it is still wet, thinning it in that area and allowing light to shine through.

Weight
The weight of a paper, which is influenced by its thickness and density, is measured in gsm, or grams per square metre.

Further Reading & Acknowledgements

314 315

Among the books consulted
during the writing of this book
or relevant to the study of identity
and branding are

How Nature Works
 Per Bak
 Oxford, 1997

Mythologies
 Roland Barthes
 Editions du Seuil, 1957

Coke!
 Stephen Bayley
 Boilerhouse, 1986

Ways of Seeing
 John Berger
 Penguin, 1976

Product Design and
Corporate Strategy
 Robert and Janet Blaich
 McGraw Hill, 1994

Design since 1945
 Peter Dormer
 Thames & Hudson, 1993

Atelier Mendini
 Frans I Menhir Haks
 Edizioni L'Archivolto, 1997

Philips
 John Heskett
 Trefoil, 1989

Olivetti
 Sybille Kicherer
 Trefoil, 1990

Industrial Design
 Raymond Loewy
 Overlook Press, 1979

The Design Dimension
 Christopher Lorenz
 Blackwell, 1986

Design Yearbook 1995
 ed. Jean Nouvel
 Laurence King, 1995

Corporate Identity
 Wally Olins
 Thames & Hudson, 1991

International Corporate Identity 1
 Wally Olins &
 Conway Lloyd Morgan
 Laurence King, 1995

Starck
 Taschen, 1995

Eloge de l'ombre
 Junichiro Tanizaki
 PUF, 1988

Archéologie
 Paul Bunker Virilio
 CCI, 1976

For a field of graphic design practice that many designers overlook in favour of the more glamourous areas of poster design, magazine and Web site design, it is interesting to note that many of the most influential designers and design critics of the last century have thought and written on the subject. Below is a list of texts, some of which are now out of print, dealing with stationery design and related subjects.

'Letters from the Avant Garde
 Ellen Lupton and
 Elaine Lustig Cohen
 Princeton Architectural Press,
 1996

'Design Coordination and
Corporate Image
 FHK Henrion and Alan Parkin,
 Reinhold Publishing Corp,
 New York, 1967

'The Graphic Designer and his
Design Problems
 Josef Müller-Brockmann
 Hastings House, New York
 1971

A History of Visual
Communication
 Josef Müller-Brockmann,
 Hastings House, New York,
 1983

'The New Typography
 Jan Tschichold, translated by
 Ruari McLean with an
 introduction by Robin Kinross,
 University of California Press,
 1995

'Design in Business Printing
 Herbert Spencer,
 Thames & Hudson, 1952

'The Letterhead: History and
Progress
 Ernst Lehner,
 Museum Books, New York,
 1955

'Paperwork
 Nancy Williams,
 Phaidon Press, 1993

316 317

The Designers	The Clients	The Activities
Grey Matter Williams & Phoa, London	Ballet-Tech, New York	Business services
HGV, London	Birds Eye, Walton-on-Thames	Charities
Lewis Moberly, London	British Airways, Heathrow	Consumer goods
Lippa Pearce, Richmond	Cearns & Brown, Shipley	Education
MetaDesign, Berlin	Coca Cola, Atlanta	Food and drink
Newell & Sorrell, London	Direct Line, London	Government organisations
Nike Design Studio, New York	Dusseldorf Airport, Dusseldorf	Leisure
Northcross, Edinburgh	Esprit Europe, London	Manufacturing
Pentagram, New York	Hong Kong Airport Core Programme, Hong Kong	
Pentagram, London	IBM, White Plains, NY	
Philips CID, Eindhoven	International Distillers, London	
Rage Design, West Wycombe	Klöckner & Co, Duisburg, Germany	
Paul Rand, New York	Lawyers Committee on Human Rights, New York	
Springpoint, London	Lec, Bognor Regis	
Studio Starck, Issy-Les-Moulineaux	OAO, Brussels	
Wolff Olins, London	Oxygen, Vienna	
	Savoy Hotels Group, London	
	Techniquest, Cardiff	
	Wineworld, London	

The Designers

Alan Dye Associates

Area

Artomatic

Atelier Works

The Attik

Azone & Associates

Bell

Billy Mawhinney

Birgit Eggers

Blast

Carnegie Orr

Conran Design Group

Factor Design

The Foundry

Frost Design

Funny Garbage

Glazer Design

Graphic Metal Company

HDR Design

HGV

Interbrand Newell & Sorrell

Intro

io360

Jaques Russell

johnson banks

Lippa Pearce

Martin Perrin

MetaDesign

Odermatt & Tissi

The Partners

Pentagram

Pyott Design

Roundel Design

Sagmeister Inc.

Sayles Design

Segura Inc.

Struktur Design

Studio Myerscough

Thomas Manss & Company

The Typography Workshop

Viva Dolan

Werner Design Works

Wild & Frey

318 319

One of the great pleasures in creating and working on this series of books is the opportunity to talk to designers about their work, and this one has been no exception. Many busy people were willing to take time to explain their own work and discuss their approach to the tasks of creating logos and identities. As well as those who are mentioned or quoted in the text, I would particularly like to thank the following: Albrecht Bangert, Jim Brown, Debbie Cox, Patrick Farrell, Stuart Flanagan, Chris Foges, Jonathan Kirk, Dominic Lippa, Ann Marshall, Kathy Merriman, Kerry Morgan, Wally Olins, Lynda Relph-Knight, Otto Riewoldt Tim Rich, Thomas Riedel, Jocelyn Senior, Janet Turner and Sally Waterman.

Special thanks also go to Angie Patchell and Wendy Williams for their editorial and design work.

Conway Lloyd Morgan, London, August 1998

An initial thank you to all of the
designers who submitted work
for inclusion in this book.

Thanks and IOUs also go to those
who helped with hints, tips and
patient advice, and those I just
bothered when they probably had
better things to do. In no particular
order: Teal Triggs, Emily Dowlen,
Robin Kinross, Patrick Baglee,
Ellen Lupton, Ruari McLean,
Nigel Roche, Dr Sue Walker,
and Angie Patchell at RotoVision,
who trusted us when we said it
would be finished soon.

In the course of research I also
visited a few institutions whose
ability to provide resources for
independent study is constantly
put under threat by the barbarians
at the gate: thanks to St Bride
Printing Library, the British Library
and the V&A's National Art Library.

Thanks also to Elaine Lustig-
Cohen, for permission to
reproduce letterheads from her
own collection, without which
kind gesture I might have been
reduced to drawing them by hand.

On that note, a big thanks also to
Xavier Young for fine photography
throughout the book.

A final, and particular thank you
goes to Roger Fawcett-Tang and
Ben Tappenden at Struktur Design,
who not only did an excellent
job with the design of the book,
but also suggested areas for
consideration.

Chris Foges